IMAGES
of America

AROUND
OSWEGO

IMAGES
of America

AROUND
OSWEGO

Terrance M. Prior and Natalie J. Siembor

ARCADIA

Published by Arcadia Publishing
Charleston SC, Chicago IL, Portsmouth NH, San Francisco CA

Printed in Great Britain

Library of Congress Catalog Card Number: 2005929077

For all general information contact Arcadia Publishing at:
Telephone 843-853-2070
Fax 843-853-0044
E-mail sales@arcadiapublishing.com
For customer service and orders:
Toll-Free 1-888-313-2665

Visit us on the internet at http://www.arcadiapublishing.com

Cover Photo: Dr. A.C. Baxter takes Mr. Burt out for a ride in Scriba, New York, c. 1908.

Contents

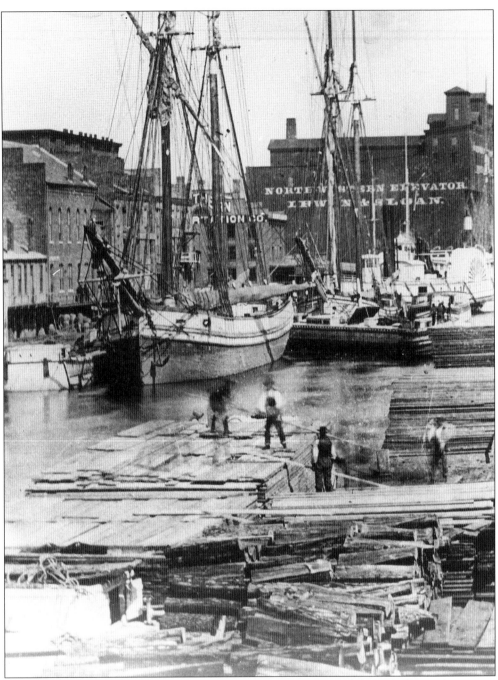

Lumber docks, c. 1875. One of the most common imports processed through Oswego's port was Canadian lumber. Stacks of lumber once lined the docks along both sides of the river and the walls dividing the freight canals from the river. Much of this lumber was used in Oswego for construction as well as for shipping crates and boxes for the Kingsford Corn Starch factory. By the turn of the century, the tall-masted schooners, side-wheel steamers, and canal freighters had become a rare sight. Railroads became the most economical way to transport raw materials into and processed goods out of Oswego.

Introduction

Oswego's unique geographical features, the Oswego River and Lake Ontario, play a significant role throughout its rich history. Numerous publications have documented the events and people of Oswego during the nineteenth century. This book, utilizing public as well as private photographic sources, will attempt to bring the more recent past into focus.

As one of the oldest freshwater ports in North America, Oswego relies as much on that resource now as it did when permanent settlers began arriving at the end of the eighteenth century. Occupied by the French and English as an important post for trading with the Native Americans, it was the construction of the Erie and Oswego canals during the 1820s that would attract commercial and industrial interest in Oswego. Instead of taking a strictly chronological approach to the photographic telling of Oswego's more recent history, this book focuses on daily experiences both past and present.

The chapter "A Tale of Two Cities" looks at the activities of Fort Ontario. Whether behind a casemate or a chain-link fence, the residents of Fort Ontario were thought of as neighbors. The occupants of the Fort formed a community of soldiers and veterans, and for a time its barracks housed European refugees seeking shelter from the Nazi holocaust. Today, Fort Ontario is a museum operated by the New York State Parks Service.

Throughout "On the Waterfront" and "Taking Care of Business," images show just how important Oswego once was as a shipping and manufacturing center. The bustling

commercial activity along the waterfront has been eclipsed by the recreational boater and the area's focus on tourism as a viable industry. Gone are the textile mills, iron foundries, rows of grain elevators, railroad freight buildings, and commercial structures which marked a thriving manufacturing economy. The new landmarks of a growing service-based economy have replaced those earlier buildings with parks, restaurants, hotels, marinas, and apartment towers. The 1960s urban renewal projects removed almost all evidence of the city's east side business district. Today, the term downtown refers almost exclusively to business on the west side of the city. The development of shopping plazas and fast food restaurants on the eastern edge of the city threaten the survival of the west side business district.

Regardless of the economic climate of Oswego, its citizens never seemed to be lacking in their efforts to take "Time Out" and "Strike Up the Band." In these chapters, recreational activities including private clubs for boating and golf, and company-sponsored picnics and bowling teams, in addition to community-wide celebrations commemorating historical anniversaries, world events, and even geographical features, provide wonderful examples of a community hard at play.

Many of you may find particular interest in the chapter "Built for Comfort." This section contains interior as well as exterior images. It includes a wide range of examples, from the formal drawing rooms of a very wealthy textile mill owner of the last century to the construction of Oswego's first public housing development in 1955.

The chapter "Faces from the Past" recognizes the people who shaped the character of Oswego. Some received national recognition with individual accomplishments, such as Congressional Medal of Honor recipient Dr. Mary E. Walker, while others worked together toward a common goal that would have a positive impact on the quality of life for all people of Oswego. In many cases, these photographs are the only evidence of the people, places, and events that have contributed to Oswego's unique character through a century of change.

One

A Tale of Two Cities

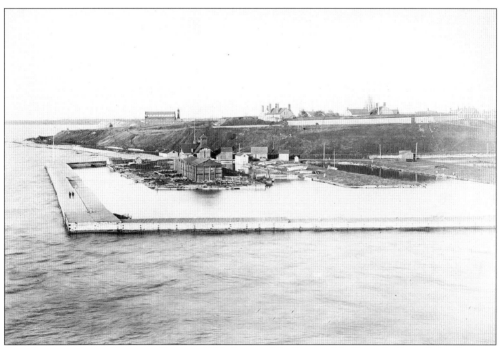

Fort Ontario above Grampus Bay, c. 1900. Located high on a bluff overlooking Lake Ontario at the mouth of the Oswego River, Fort Ontario has been a significant "neighborhood" in Oswego for over two hundred years. The surviving buildings within the fortification were erected between 1838 and 1870. Between 1903 and 1905 a battalion-sized complex of red brick buildings was constructed on the outer works. During the first half of this century, the Fort was used for a number of military activities, as a World War II refugee shelter, and as housing for veterans. The federal government transferred the Fort to New York State in 1946.

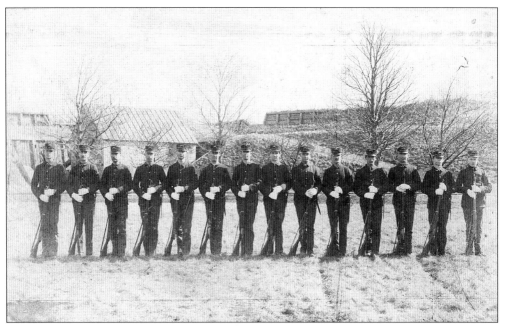

Fort Ontario, March 11, 1899. Prior to being shipped off to the Philippines, members of Company C, 9th U.S. Infantry, posed for the camera. From left to right, they are: C. Meeker, J. Gordon, J.J. O'Neal, G. Allen, C. Powers, W. Burke, Jas. O'Neal, O. O'Neal, W. Archambo, R. Walsh, H. Trapp, S. Burke, D. Donovan, and Roland T. Clark.

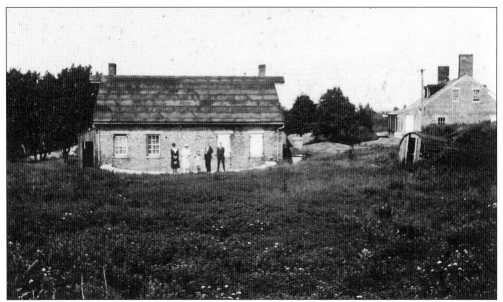

Old Fort Ontario, c. 1905. With the newly constructed brick buildings outside the old fortification in service, Fort Ontario lay empty and boarded. City residents thought it was an ideal site for picnics.

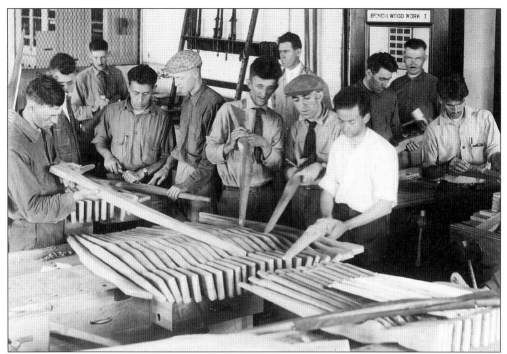

Fort Ontario soldiers, *c*. 1917. During World War I, soldiers from the Fort enrolled in several vocational and technical classes at the Oswego Normal School. Here they try their hands at making gun stocks.

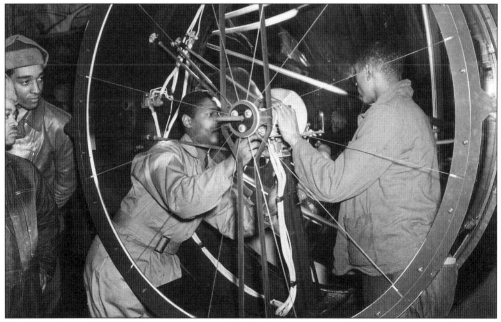

Fort Ontario, *c*. 1941. Soldiers get acquainted with the latest state-of-the-art equipment. Between January and September of 1941, the all-African-American 369th Coast Artillery Regiment was stationed at the Fort. Consisting of two battalions of anti-aircraft and one searchlight battalion, the 369th was sent to Oswego to train on the shore of Lake Ontario.

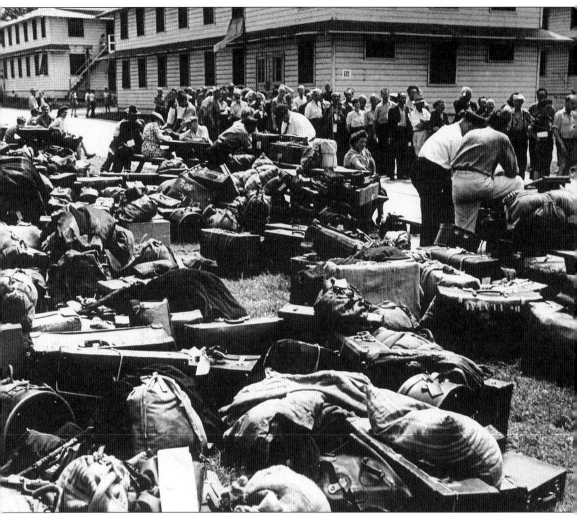

Fort Ontario, August 5, 1944. In June 1944, President Franklin D. Roosevelt announced that he was establishing a camp for approximately one hundred European refugees at Oswego's Fort Ontario. A final total of 982 Jewish, Catholic, Greek Orthodox, and Protestant survivors of the Nazi holocaust were transported from Italy to the United States. They arrived in Oswego with the understanding that they must return to their homelands at the end of the war—but apparently only sixty-nine actually did. Throughout their eighteen-month confinement at the Fort they strove very hard to make life there as normal as possible.

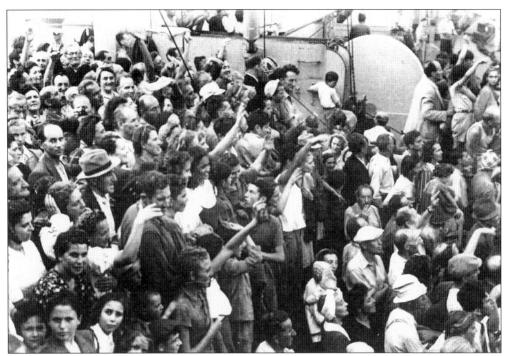

Refugees entering New York Harbor aboard the troop transport ship *Henry Gibbons*, August 1944.

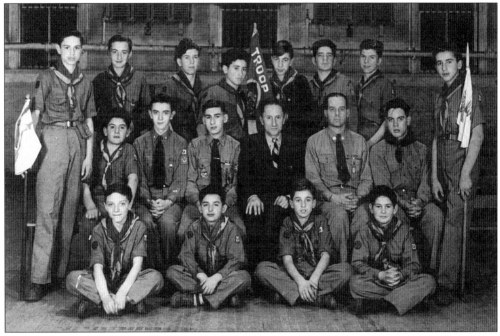

Shelter Boy Scout Troop #23, January 1946. Harold Clark of Minetto organized a Boy Scout troop at the shelter shortly after the refugees arrived. Clark later received the Silver Beaver award for his dedication and hard work. The man in the suit was the troop's interpreter. A Girl Scout troop was eventually organized for the young girls in the shelter.

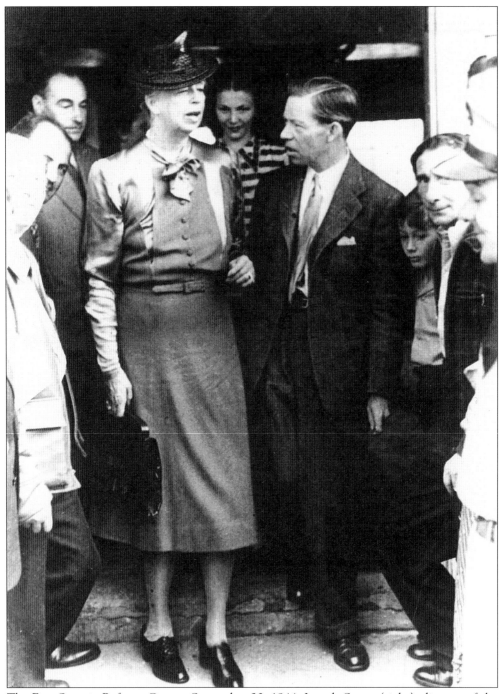

The Fort Ontario Refugee Center, September 20, 1944. Joseph Smart (right), director of the refugee center, welcomes First Lady Eleanor Roosevelt for a tour of the shelter. In addition to the shelter residents, everyone in Oswego turned out to greet Mrs. Roosevelt.

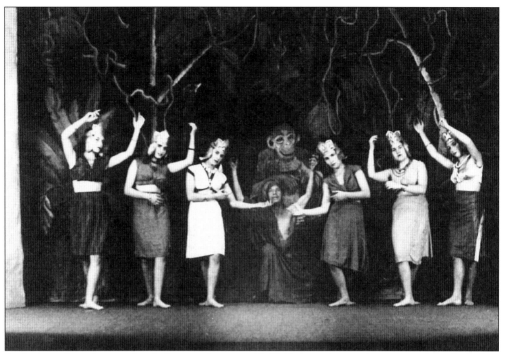

A theatrical production by shelter residents, *c.* 1945. Private agencies cooperating with shelter staff sponsored educational and leisure-time activities designed to relieve the monotony of confinement at the shelter. Several of the singers and musicians in the shelter performed in Oswego and nearby towns.

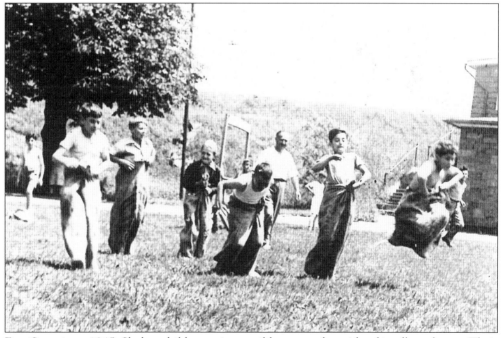

Fort Ontario, *c.* 1945. Shelter children enjoy a mild summer day with a friendly sack race. Their American counterparts were probably enjoying their summer break with similar activities.

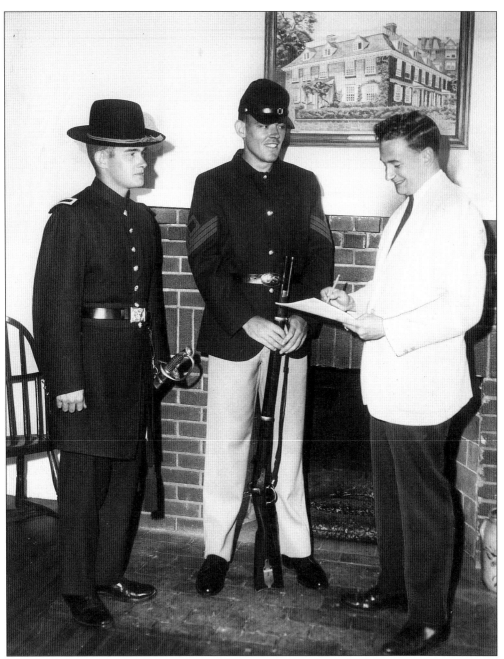

The Fort Ontario Historic Site, c. 1962. No longer used by the federal government after World War II, Fort Ontario became a State Historic Site in 1949. Today, the Fort Ontario Guard, guides, and costumed interpreters bring to life the Fort's rich history. Here, Museum Curator Wallace Workmaster readies guards Kenneth White and Richard Camp for another season.

Two

On the Waterfront

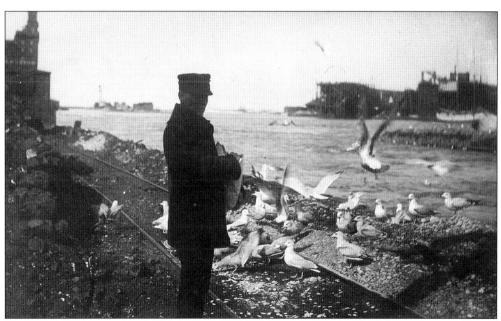

The Oswego waterfront, *c.* 1920. Oswego flourished as a port city through the 1870s. Salt from Syracuse and grain milled locally were both shipped from here destined for markets in the upper Great Lakes. By the 1880s, other sources of salt became available and the new larger grain ships could no longer enter the port. Coal became the new commodity passing through Oswego, and coal trestles replaced the grain elevators.

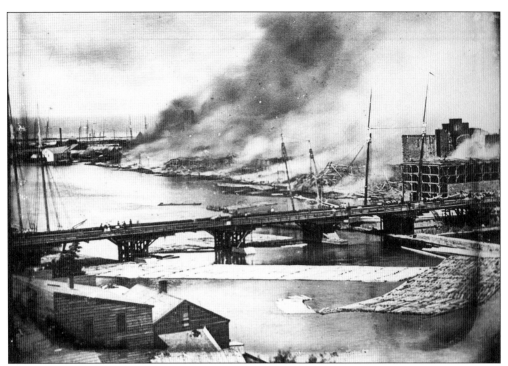

City on fire, July 5, 1853, the George Eastman House. Beginning in the Fitzhugh flour mill on the east bank of the river and quickly spreading, the fire so vividly captured here destroyed not only fourteen flour mills and grain elevators, but also most of the homes and businesses north of East Bridge Street to Fourth.

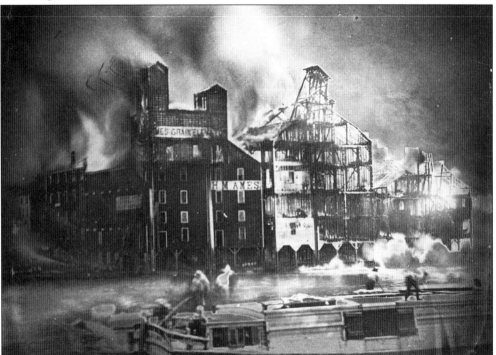

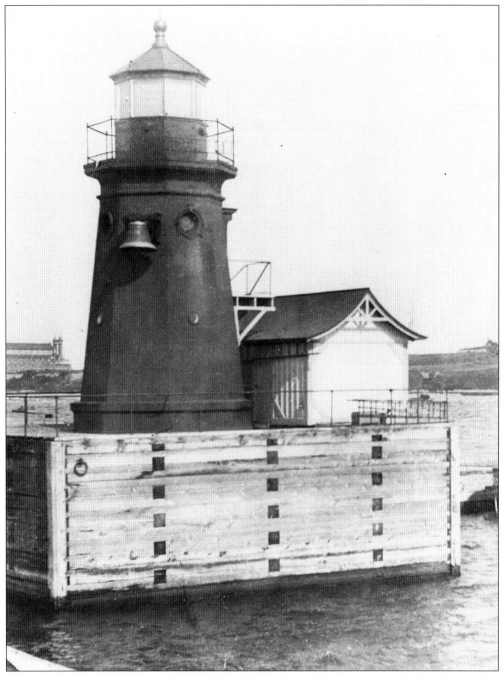

The outer harbor lighthouse, *c.* 1906. Built in 1881 along with the new wooden breakwater, the outer harbor light served with the inner harbor lighthouse to guide ships into the harbor. The building to the left was the Oswego Maize Products factory on East Ninth Street.

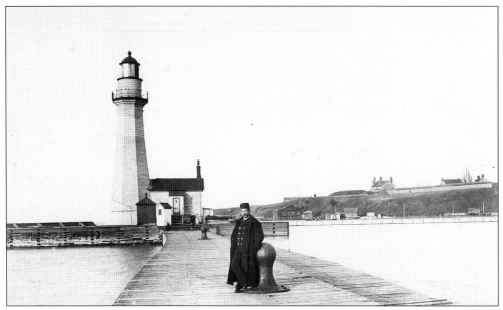

The inner harbor lighthouse, *c.* 1899. Originally built in 1838, it was raised and a new light added in 1869. Ships could tie up alongside the pier to unload passengers.

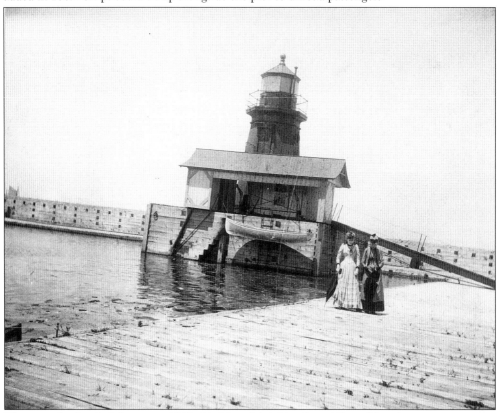

The outer harbor lighthouse, *c.* 1888–91. Mrs. G.M. Plumb and Rosie Hamilton are enjoying a walk out on the pier.

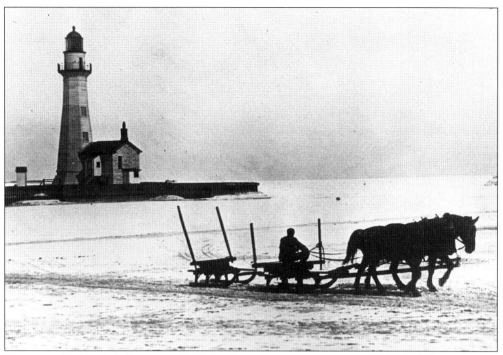

The inner harbor lighthouse, c. 1900. In the winter, paying a visit to the lighthouse keeper could be done in something other than a boat.

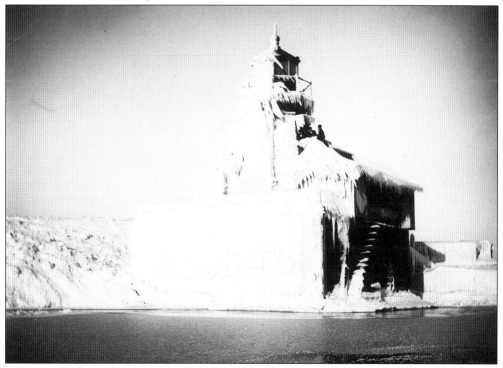

The outer harbor lighthouse, c. 1900. A cocoon of ice signals the close of the port for another season.

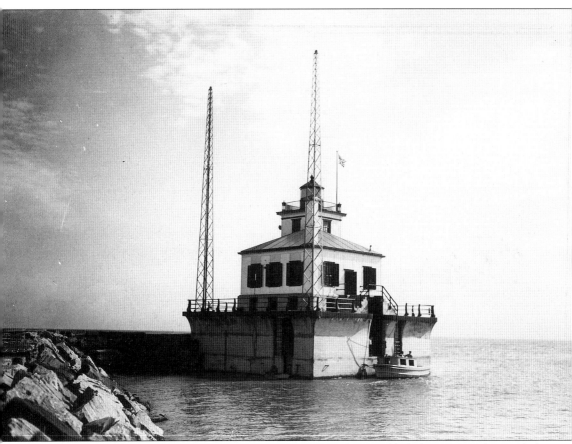

The harbor lighthouse, c. 1934–43. The wooden piers and original lighthouse were dismantled in the 1930s and the present lighthouse was erected. Still lighting the way to a safe harbor, the lighthouse was automated in 1943 after a fatal accident claimed the lives of six Coast Guardsmen on their way to service the light.

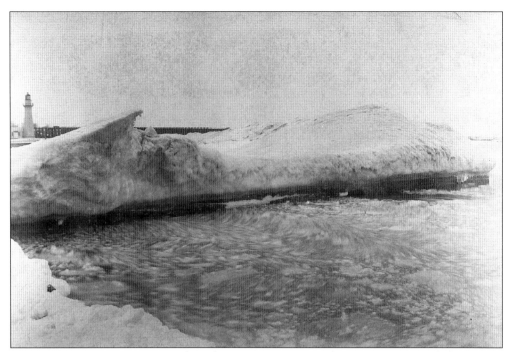

Oswego harbor, c. 1895. Winter has always given nature a chance to create some interesting ice sculptures along the waterfront. Unfortunately, these became hazards to ships entering the harbor in early spring.

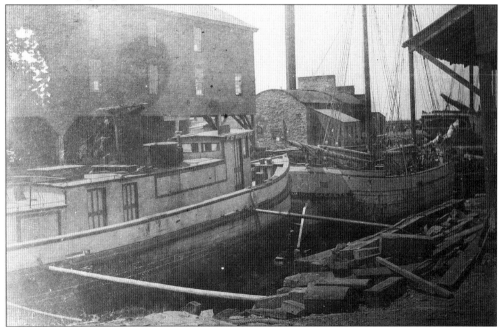

Goble's dry dock, c. 1890. Located at the foot of West Second Street, George Goble's boatyard was actively building tugs and schooners from the 1850s through the late 1880s. The company managed to hang on until the early 1900s as a repair yard for many of the boats and schooners they made.

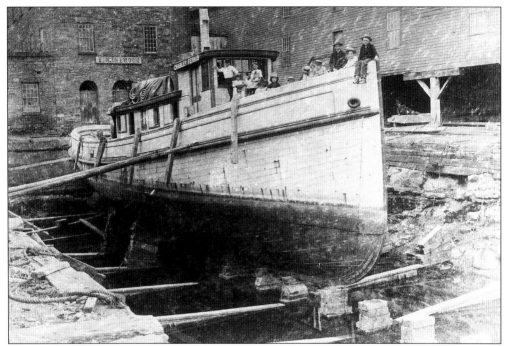

Goble's dry dock, *c.* 1890. Children pose on the deck of the dry-docked tug *Charlie Ferris*. The *Charlie Ferris* was built at the Goble yard.

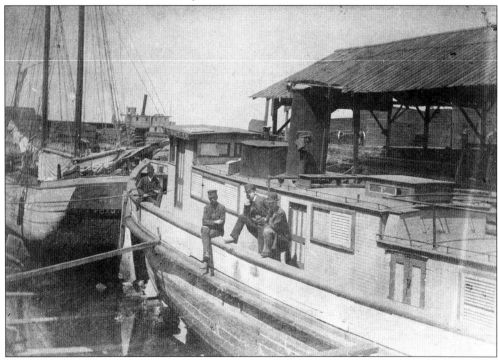

Goble's dry dock, *c.* 1890. Visitors lounge on the decks of the tug *F.D. Wheeler* while it receives some repairs. Perhaps they are the captain and crew wondering how long before they will be back on the water.

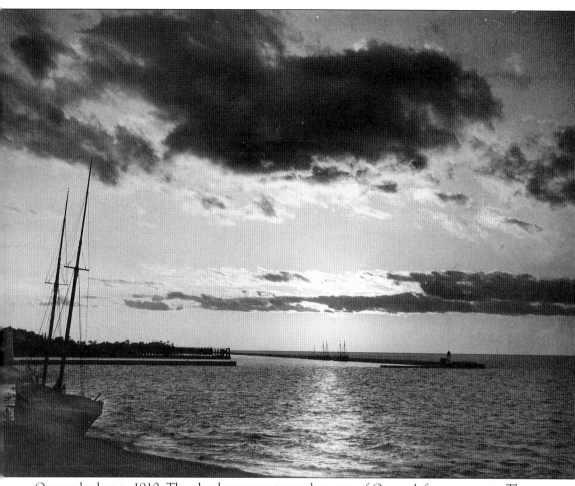

Oswego harbor, c. 1910. The clouds open up to produce one of Oswego's famous sunsets. The preceding storm apparently took its toll on another unprepared schooner. Perhaps it was later towed to Goble's dry dock for repairs. The inner harbor lighthouse (at left) was removed in the 1920s to make way for a new pier and the state's grain elevator.

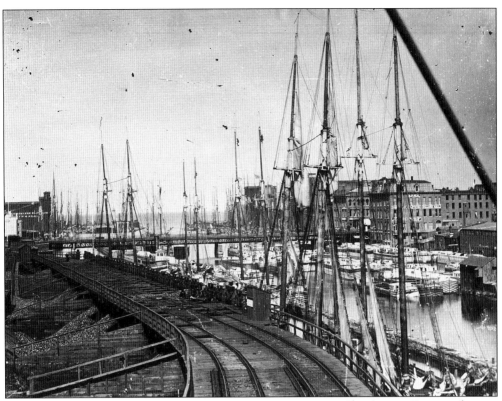

The Oswego River and harbor, c. 1870. The old Bridge Street bridge could be opened mechanically to allow the tall-masted schooners access to the coal bins along the west bank of the river.

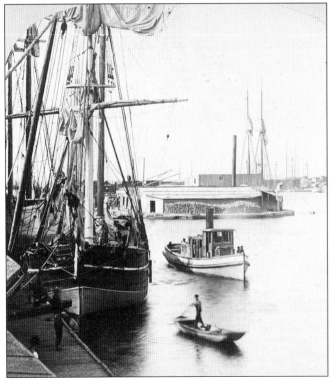

Oswego harbor, c. 1870. Longshoremen and boat tenders ply their trade during the heyday of shipping. The steam tugs were kept busy towing the masted schooners safely to the docks.

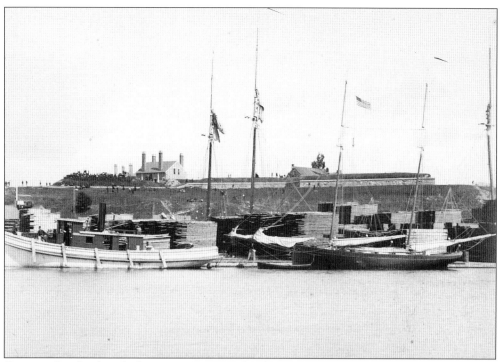

Grampus Bay lumber docks, c. 1885–90. Under the watchful eye of Fort Ontario's casemates, docks leased by Canadian firms held lumber waiting to be shipped to other ports.

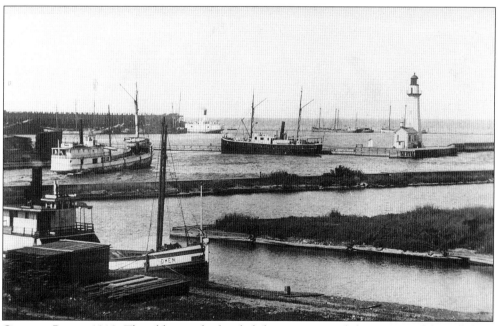

Grampus Bay, c. 1910. The old inner harbor lighthouse witnessed the passing of the tall ships and the lumber trade. Grampus Bay was filled in the 1960s to make way for the construction of the Port of Oswego Authority's east terminal warehouse.

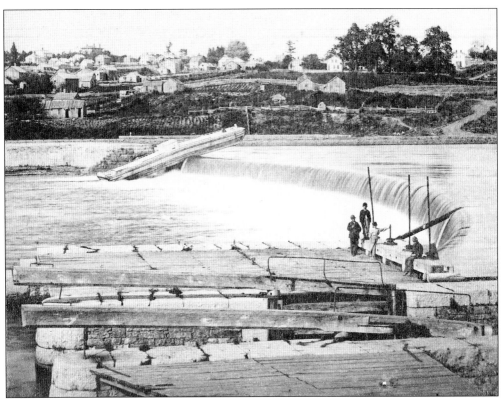

The Oswego Canal and River, *c*. 1880. Accidents like this were pretty rare along the canal. The mules towing the canal freighters usually kept the boats on course and through the locks.

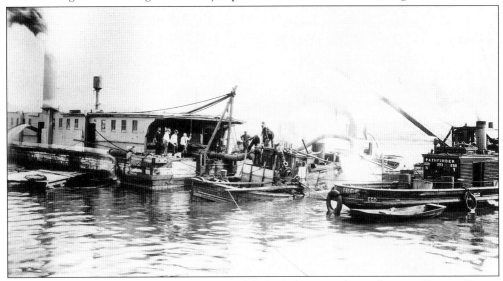

Oswego harbor, *c*. 1914. The Oswego tug *Pathfinder* helps raise the sunken tug *Erastus Day* to clear the shipping channel. As the days of serving as schooner escorts passed, the work of tugs in Oswego changed. By the 1910s, there were fewer schooners visiting the harbor, and the tugs diminished in number. From this time forward, tugs were used mainly for special projects like this one.

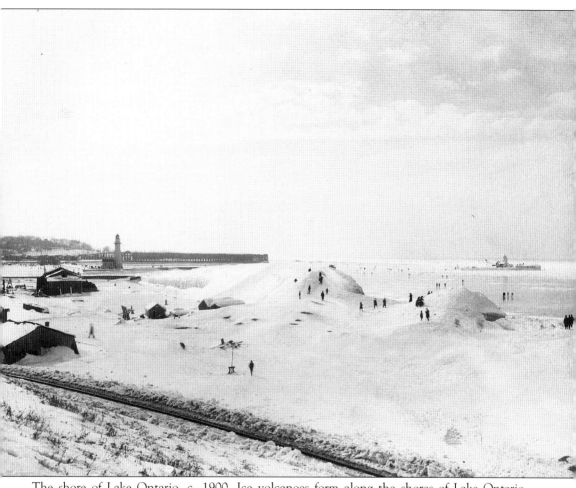

The shore of Lake Ontario, c. 1900. Ice volcanoes form along the shores of Lake Ontario during prolonged winter months and attract sightseers foolish enough to explore the unstable temporary landscape. The construction of a breakwater spelled the end of the volcanoes in the harbor area, although they still form outside the confines of the breakwater.

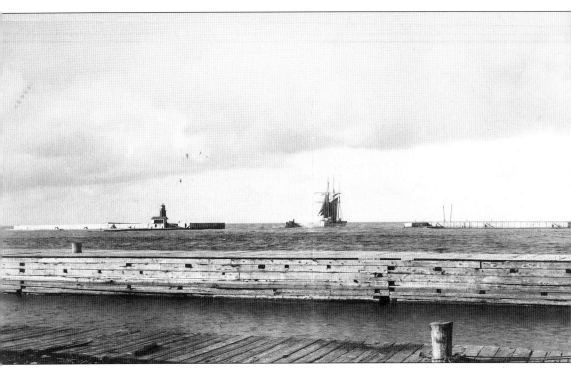

Oswego harbor, c. 1890. Tugs were essential to the working business of any Great Lakes port during the late nineteenth century. These tugs were used to escort the large schooners into the shipping channels and past the breakwaters.

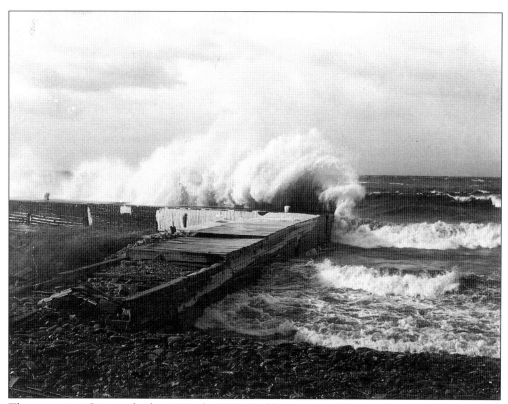

The east pier, Oswego harbor, March 1906. Sudden storms with treacherous whitecaps and dangerous undertows are a common hazard on the Great Lakes.

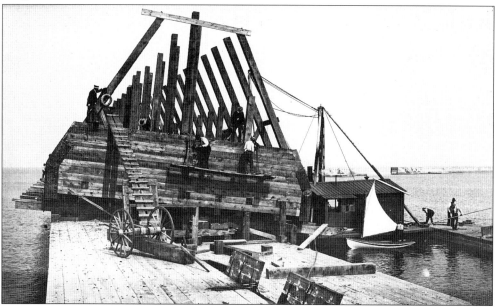

Building the outer harbor breakwater, July 1889. Made of hemlock, white pine, and white oak, this arm of the wooden breakwater was designed to be partially filled with stone, towed, and then sunk into place.

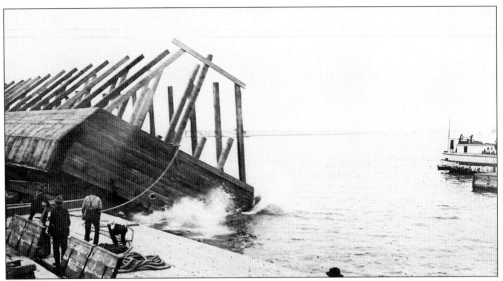

Launching the breakwater, September 1889. Equipped with a water gate on one end to flood the interior, the breakwater was launched before being towed into position. There the upper deck was completed after more stone was added, for a total ballast of 4,200 tons.

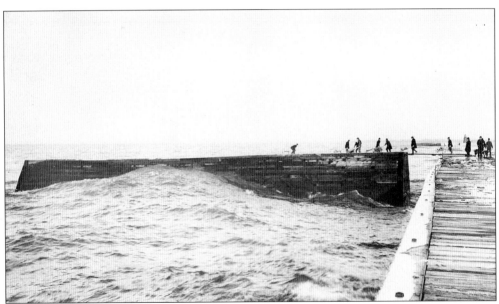

Checking the breakwater after a heavy gale, December 1889. No damage was found on this inspection of the works, though the winds had been severe. These wooden works remained in place until the 1930s.

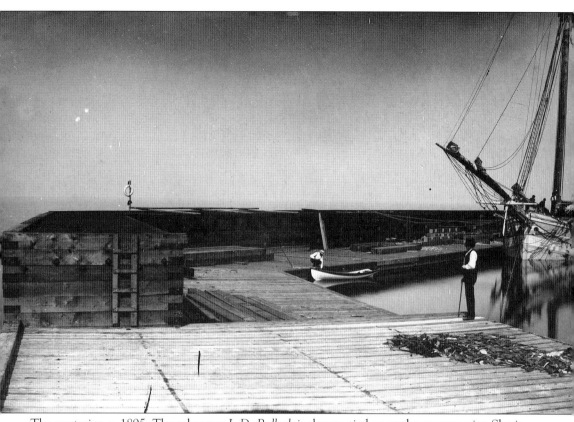

The west pier, *c.* 1895. The schooner *L.D. Bullock* is shown, tied up at the western pier. She is probably carrying a cargo of lumber since this is what is piled on the dock beside her. Nearby is a dock tender with one of the many sleek craft once used to shuttle around the harbor.

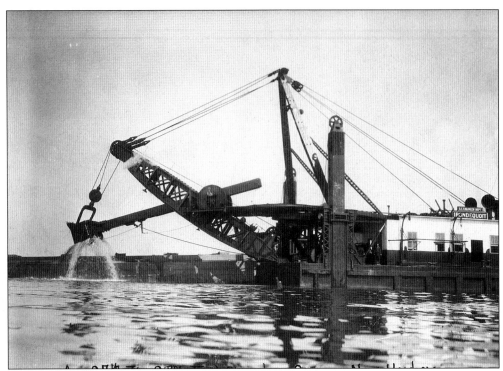

The steam shovel Irondequoit, August 27, 1930. Work on the current stone breakwater began in 1930. One of the hazards to shipping in Oswego harbor is excessive silting caused by debris coming down the Oswego River. Keeping the channel clear means periodic dredging by shovels such as the Irondequoit and others.

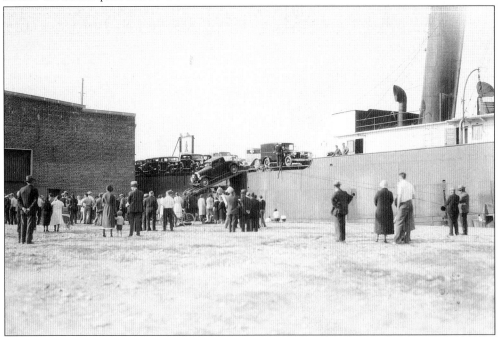

The Port Authority west terminal, c. 1932. Spectators watch cars being unloaded.

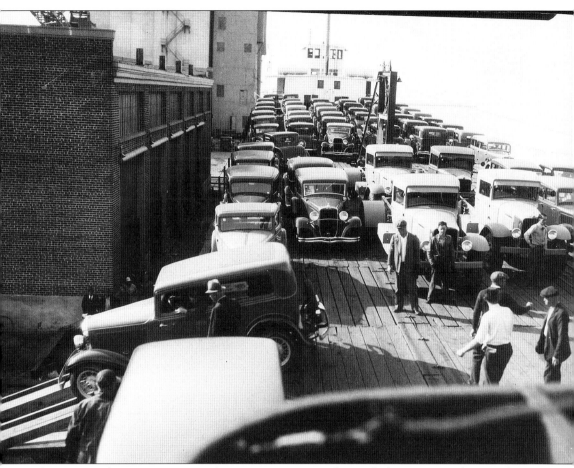

The Port Authority west terminal, c. 1932. In 1932, the Nicholson Universal Steamship Company began shipping automobiles through Oswego. That year 6,500 vehicles were scheduled to have been shipped through Oswego. Here are some of them coming off the ramp near the west side grain elevator. They were shipped according to the following rates: from Buffalo, $6 per car; from Detroit or Toledo, $13.50–19.50; and from Milwaukee, $29.50–35.50. Vehicles over 18 feet added 50¢. These cars and trucks appear to have been mostly Plymouths based on the grilles and hubcaps.

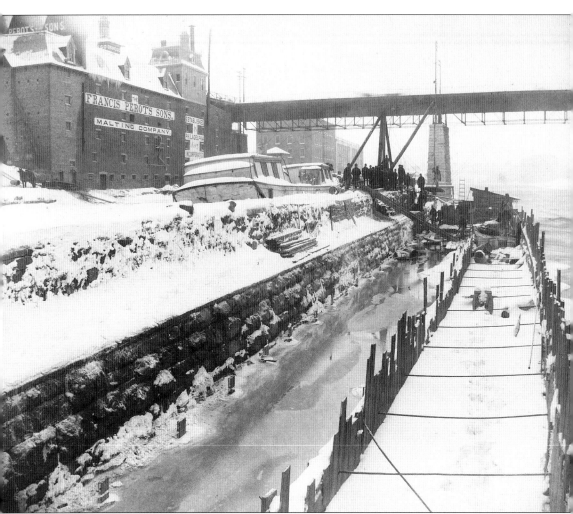

The Oswego Canal, c. 1899. Perot's Malt Company on East First Street forms the backdrop for this scene on the canal. Before Prohibition, Oswego, like most communities in the United States, supported a number of small local breweries. In order to supply them, most towns also had malt houses where the barley was malted and roasted. In 1899, Oswego had four malt houses and at least two of them may have also brewed on the premises. During the 1890s, there were also numerous chapters of the Temperance Union active in the city.

Three

Taking Care of Business

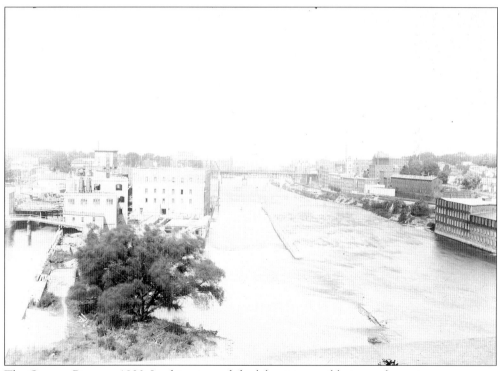

The Oswego River, c. 1920. Looking toward the lake, it is possible to see the various ways water was diverted from the river for the development of factories and mills. To the left is the Varick Canal and the Kingsford Corn Starch plant; to the right are the textile mills, the Oswego Canal, and the hydraulic canal.

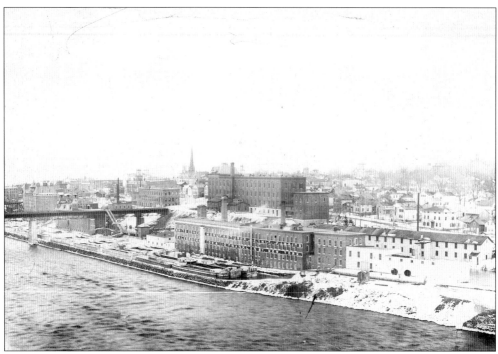

The Oswego River, *c*. 1882. Textile mills, employing hundreds of laborers, once lined the water's edge. Here, along the east bank of the canal, the Condé Knitting Mill stands in the shadow of the Oswego Shade Cloth factory. Power to run the machinery was generated by the hydraulic canal running between the two complexes.

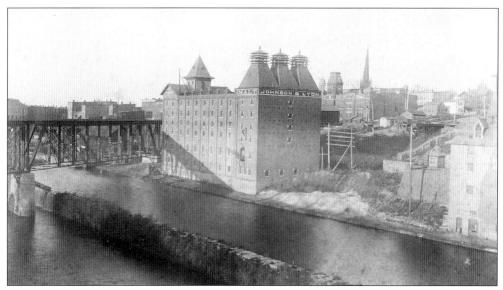

The Johnson & Lyon Malt House, *c*. 1893. Johnson & Lyon, at the foot of East Mohawk Street, was one of seven maltsters operating in 1893. The tower atop the old Armory building appears between the County Court House dome and the church steeple.

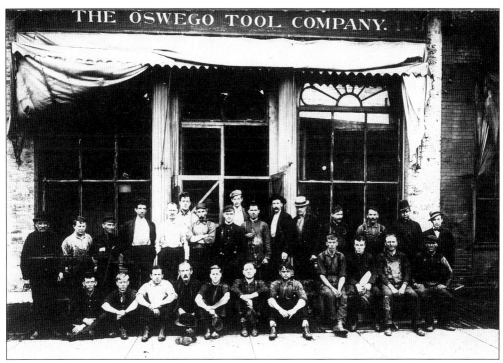

The Oswego Tool Company, August 21, 1901. Started by former Kingsford Foundry employees, this business at 125 West First Street was one of several examples of the entrepreneurial spirit in Oswego.

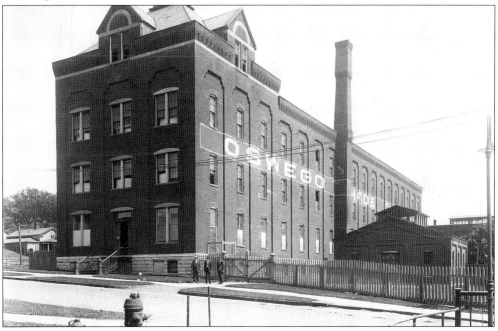

The Oswego Shade Cloth Company, c. 1922. Located along the hydraulic canal at East First and Utica Streets, this was the longest operating mill in the city. It finally closed its doors in the 1970s.

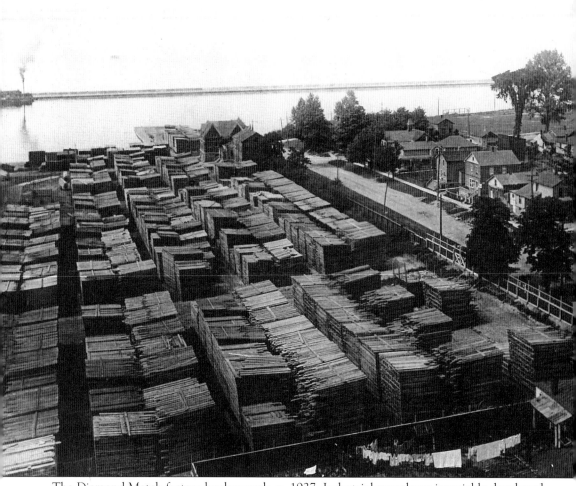

The Diamond Match factory lumber yards, c. 1927. Industrial complexes invariably developed alongside working-class neighborhoods. These worker's houses are typical of many of the neighborhoods in Oswego. The owners and managers of factories generally lived in better neighborhoods away from the plants. Here we can see someone's laundry drying on the line. Near the trees in the upper right is the baseball field the company provided for the workers and the neighborhood.

The Oswego Car Spring factory, c. 1890. This shop was located along West Schuyler Street adjacent to the Diamond Match factory complex. When the parts they manufactured for railroad cars were no longer needed, the building became part of the match factory. The excavation is apparently in anticipation of business expansion.

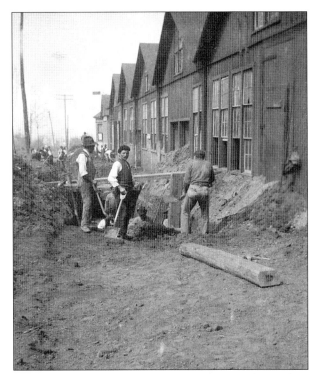

The chocolate factory at 275 West First Street, June 6, 1953. David D. Long built the Oswego Candy Works on this site in 1902. It operated as Long's Oswego Candy Works until 1946, when it was acquired by the Russell McPhail Company. The factory was operated by a declining staff until 1976 and was destroyed by a fire on March 24, 1978.

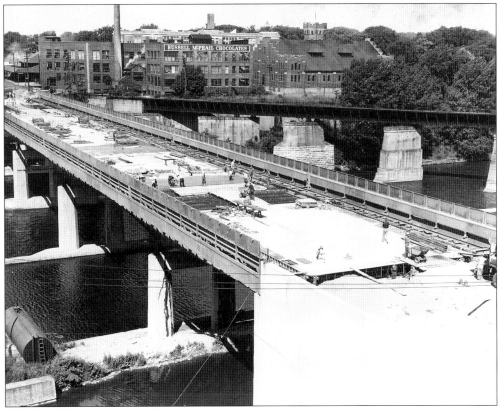

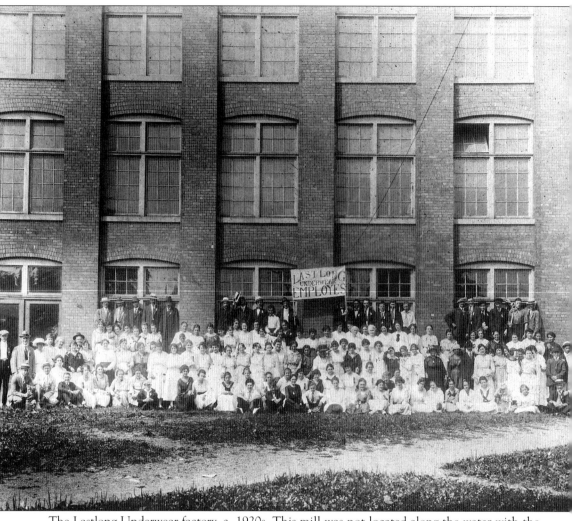

The Lastlong Underwear factory, c. 1920s. This mill was not located along the water with the mills from the earlier period. It was located in a working-class neighborhood on East Ninth Street. The large number of women available to work in the garment industry in Oswego attracted small production knit underwear factories. These workers apparently had little time for education—they misspelled "Employees." Throughout the 1950s and '60s, the textile mills began to shut down, leaving a work force looking to learn new skills.

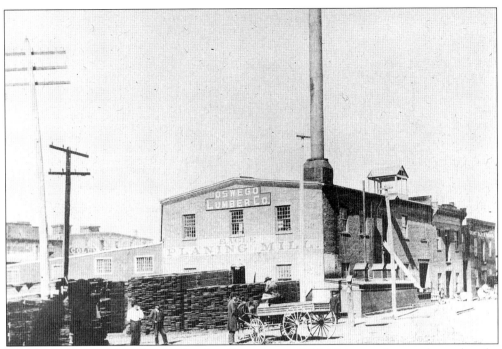

The Eagle Planing Mill/ Oswego Lumber Company, *c.* 1892. This complex was located at the corner of East Second and Cayuga Streets—near the present site of the T.J. Burke Lumber Company. The rapid construction of the housing needed for immigrants coming into Oswego kept the local lumber yards busy.

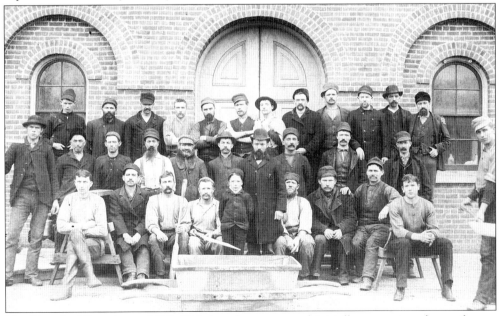

The Kingsford Foundry, *c.* 1880. This foundry was started initially to repair and manufacture machine parts for Kingsford's corn starch plant. In the 1880s they added the production of large industrial boilers to their line of products. Here, the construction workers who were responsible for the building expansion project pose for the camera.

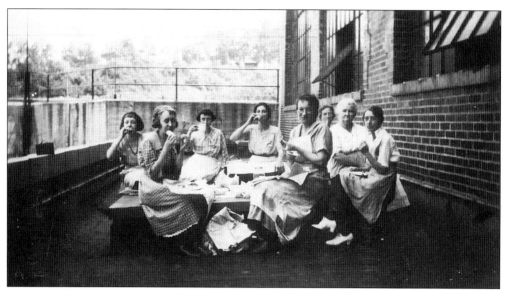

The Columbia Mills factory, August 1921. Florence Sheffield, Mrs. Brennan, Rhoda Crouch, Myrtle Dodge, Elsie Northorp, Mrs. Czar, and Mrs. Bickford enjoy a lunch break outside the factory.

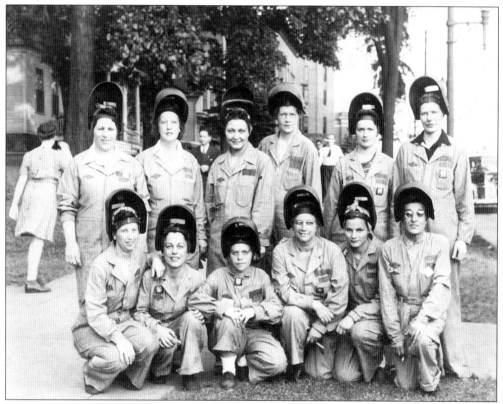

Women welders, *c.* 1943. With the men off fighting, women played key roles in the manufacture of war materials. These women worked at the Fitzgibbons plant on tanks like the one on p. 51.

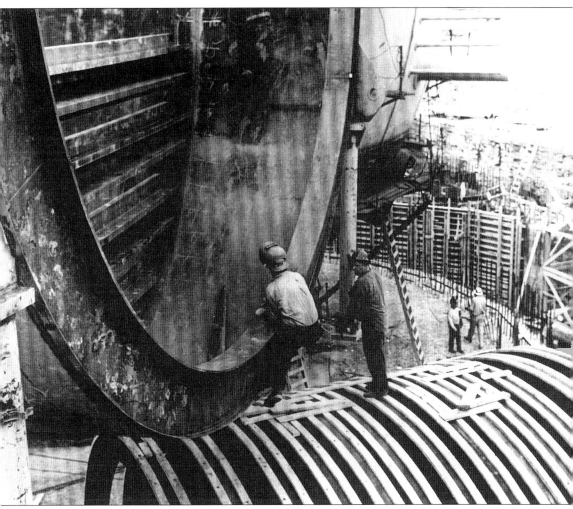

Nine Mile One, January 1966. Oswego entered the nuclear age in the 1960s with the construction of the first of three nuclear facilities, ending the era of hydroelectric dependency which had built most of the communities along the Oswego River valley. Construction of these plants provided a large number of jobs for the community. Here welders assemble the reactor.

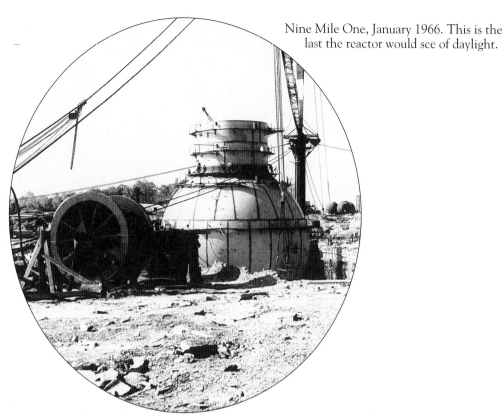

Nine Mile One, January 1966. This is the last the reactor would see of daylight.

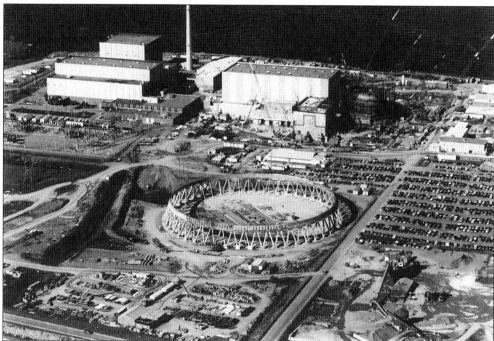

Nine Mile Point, c. 1980. From the air one can truly assess the size of the nuclear plant layout. When completed, the cooling tower, in the center, would reach a few hundred feet in height.

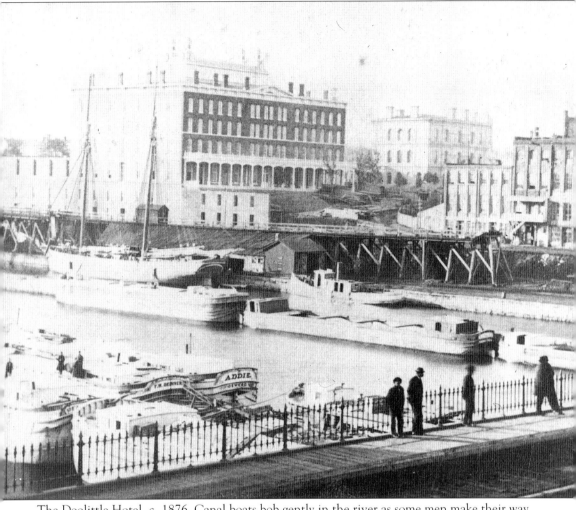

The Doolittle Hotel, c. 1876. Canal boats bob gently in the river as some men make their way across the Bridge Street bridge. Looking west is the Doolittle Hotel, later the site of the Pontiac Hotel, and to its right is the U.S. Customs House—now an annex to City Hall.

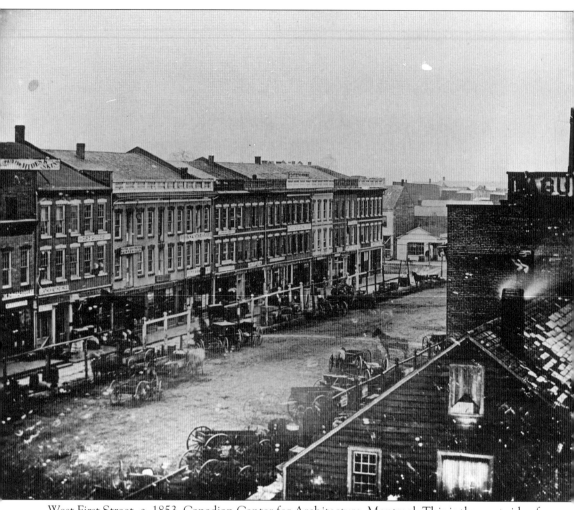

West First Street, *c.* 1853, Canadian Center for Architecture, Montreal. This is the west side of the street between Cayuga and Seneca Streets. Buggies and wagons are tied up to the hitching posts lining the street. Buildings essentially formed the blocks since many of them shared common walls. Unfortunately, that was the reason fires so drastically rearranged the look of the city.

West First Street, July 12, 1894. Apparently the photographer had a sense of humor—written across the bottom was "A Busy Day In Oswego, N.Y."

West First Street, c. 1876. Many of the buildings are decked out in preparation for the celebration of the country's centennial. The Lake Ontario National Bank (at right) and the First National Bank (at left) were only two of the eight banks operating in the city.

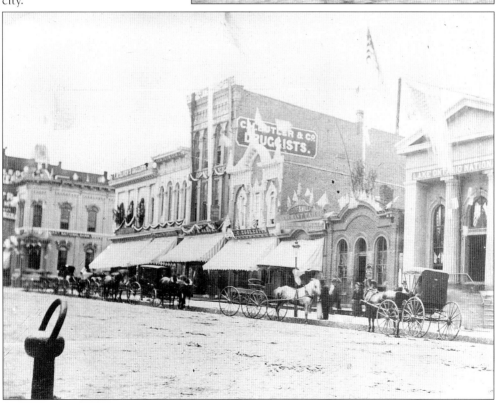

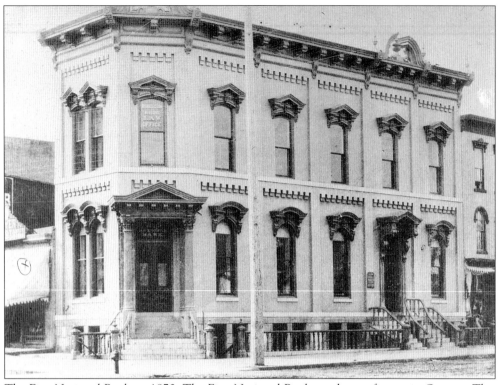

The First National Bank, c. 1870. The First National Bank was long a fixture in Oswego. This particular building was on the corner of West First and Bridge Streets until 1910.

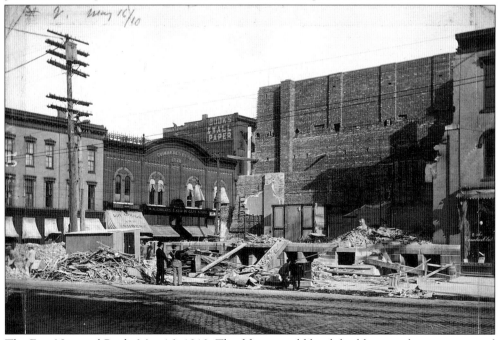

The First National Bank, May 16, 1910. The fifty-year-old brick building on this site was razed to make way for a new marble and granite structure which still stands today.

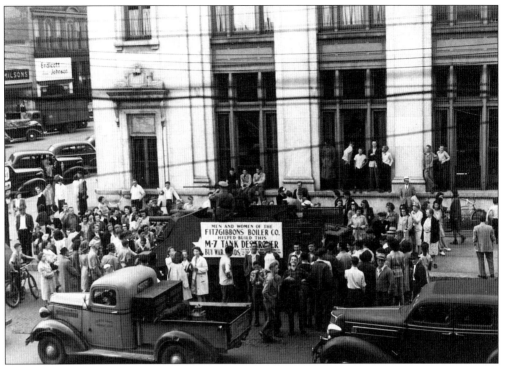

The First National Bank, *c.* 1943. Used for more than holding money, the building supported spectators who came out to see Oswego's contribution to the war effort.

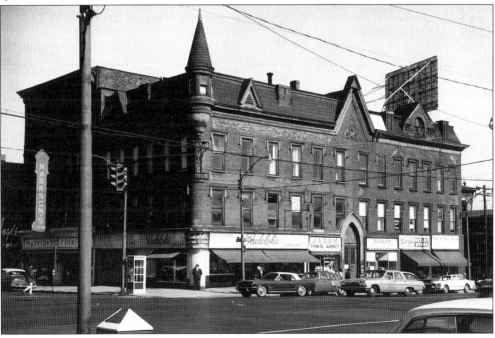

The Buckout-Jones building at the corner of West First and Bridge Streets, *c.* 1965. This building has long been a landmark in the west side business district. When this view was taken, the Rochester Business Institute had already vacated the upper floors.

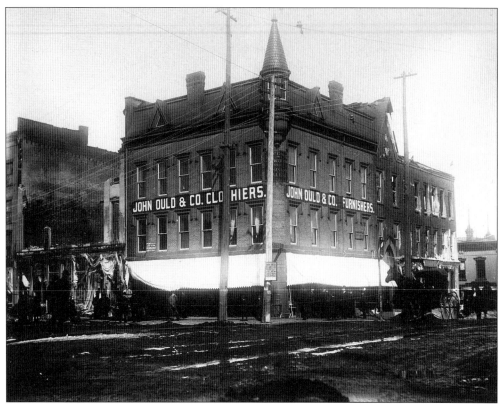

West First Street, *c*. 1890. Numerous fires in the nineteenth century continued to change the face of the business district. In better economic times, the damaged buildings or empty lots were quickly rebuilt. Today, numerous empty spaces break up the once-continuous business skyline.

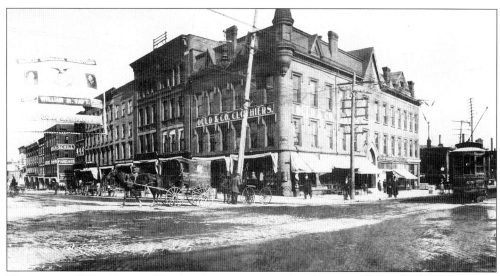

The corner of West First and Bridge Streets, *c*. 1908. An electric trolley rolls along the brick-surfaced streets of the business district, competing with horse-drawn carriages for right-of-way.

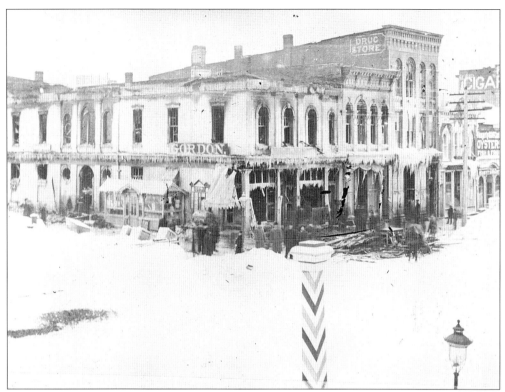

The aftermath of a devastating fire at the Gordon's Dry Goods store, January 28, 1881. Within the year, the entire northwest corner of West First Street was rebuilt. The barber shop pole at the center witnessed it all.

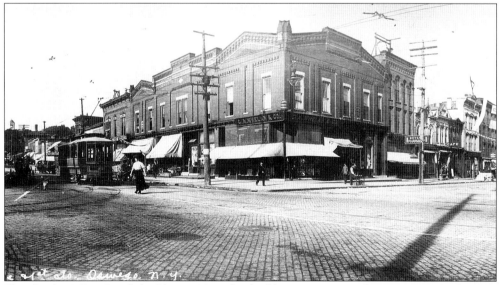

The Gordon's Dry Goods building, 1908. This building continues to be a mainstay in the west side business district.

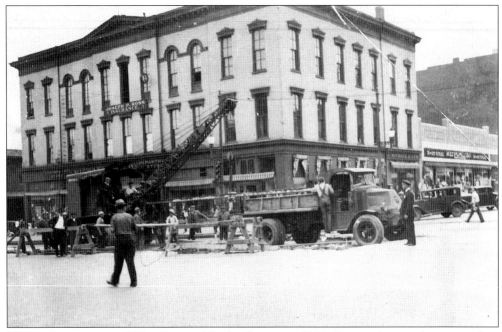

The southeast corner of West First and Bridge Streets, *c.* 1937. City workers are busy upgrading the sewer system. This three-story building would be razed to make way for an expansion to H.L. Green's Metropolitan department store.

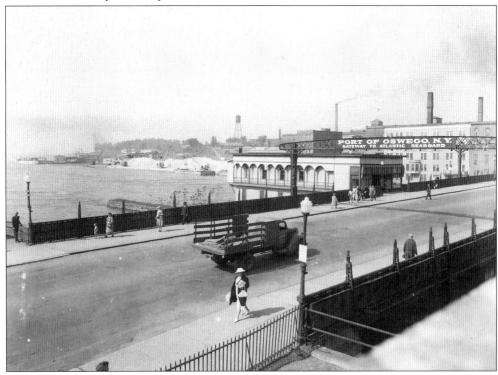

The Bridge Street bridge, *c.* 1943. One of the more unusual locations for retail, McKay's shoe and hat shop was actually on the bridge, serving customers until 1957.

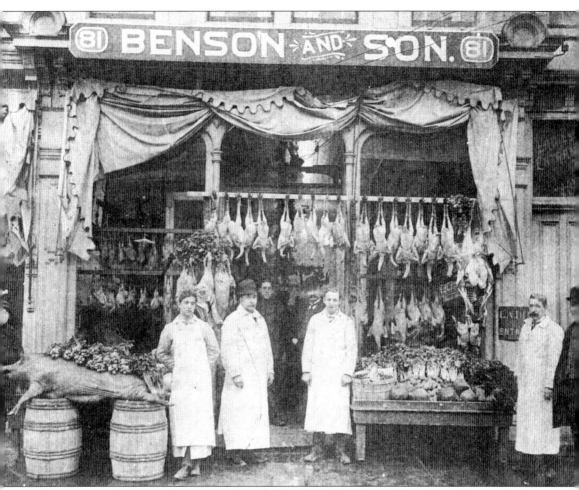

The Benson and Son market, *c.* 1910. This business was located at 81 East Second Street from 1890 until 1943. Patrons could make their selection from duck, rabbit, turkey, chicken, beef, lamb, and of course, pork. Small family-owned markets such as this would eventually give way to the familiar supermarkets of today. The sign above the door at the right signified the segregated entrance to a restaurant or hotel dining room.

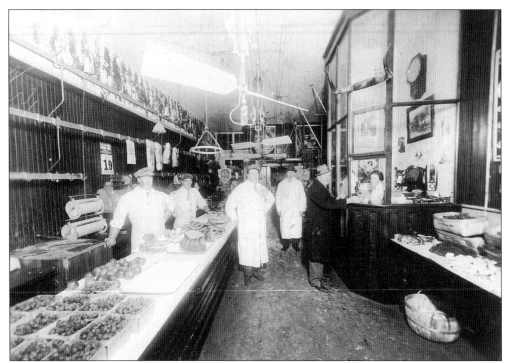

An interior view of the Benson and Son market on East Second Street, *c.* 1913. Perhaps those are locally grown strawberries for sale on the counter.

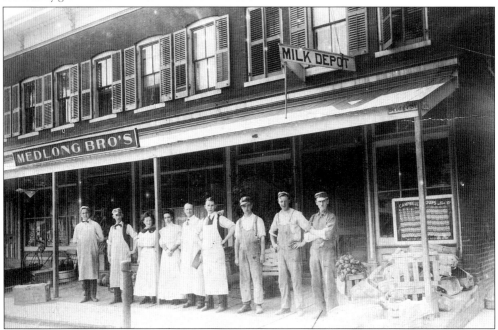

The Medlong Brothers market, *c.* 1900. This grocery was located at 155 East Bridge Street from 1882 until 1946. Medlong's was one of the many small markets serving Oswego's neighborhoods. Today, Garafolo's Importing Company sells its famous Italian sausage from this building.

Dick Hawkins with two employees, *c.* 1896. This upholstery business was located at 139 West Bridge Street. Apparently they thought donning their hats would make for a more formal portrait.

Fred Riley's Insurance office, *c.* 1925. This office was located at 12 East Bridge Street from 1902 until the urban renewal projects razed much of the east side business district in the early 1960s. Wonder what special occasion prompted all the flowers?

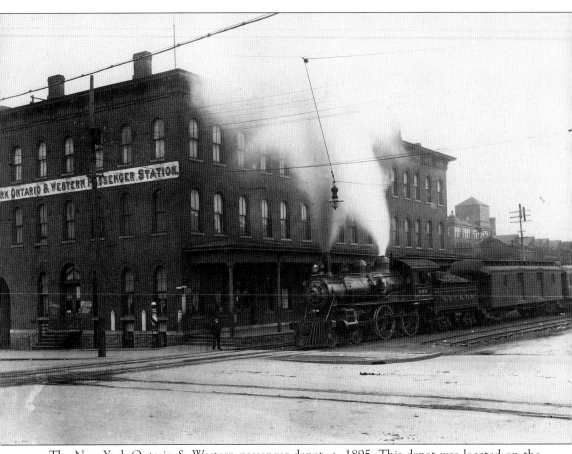

The New York Ontario & Western passenger depot, c. 1895. This depot was located on the corner of East Third and Bridge Streets. The O&W offered passenger service twice daily to New York City on first-class trains with reclining chairs on night trains. The familiar passenger train suspended operation of the Oswego depot in the 1936. Here, New York Central & Hudson River Railroad Engine #999, reportedly one of the company's fastest locomotives, waits for passengers to board. Perhaps someone is taking too long at the barber shop on the corner.

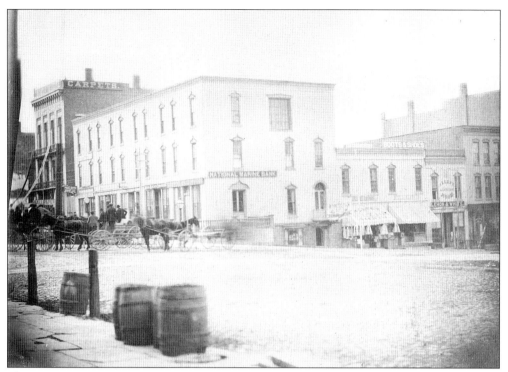

The Marine National Bank, *c*. 1869. Located at the southwest corner of East First and Bridge Streets, it was the first bank at this location.

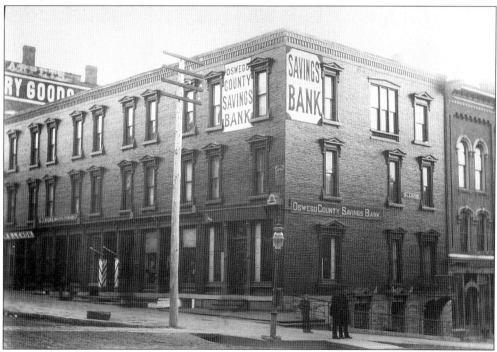

The Oswego County Savings Bank, *c*. 1889. Shortly after the County Savings Bank organized, they rented space vacated by the Marine National Bank.

The Hungerford Block, *c.* 1873. This group of buildings was located along the south side of East Bridge Street between the bridge and First Street. At this time, Kiem's shoes and Garson's were built out over a portion of the canal.

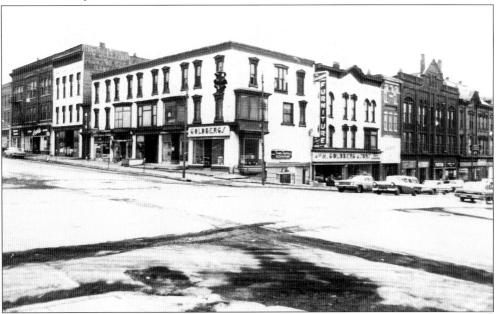

Another view of the southwest corner of East First and Bridge Streets (see p. 59), *c.* 1962. From the 1860s to the early 1960s, this corner changed very little. However, all of these buildings would be razed as part of the urban renewal projects of the early 1960s. Today, this is the site of a Marine Midland Bank branch office.

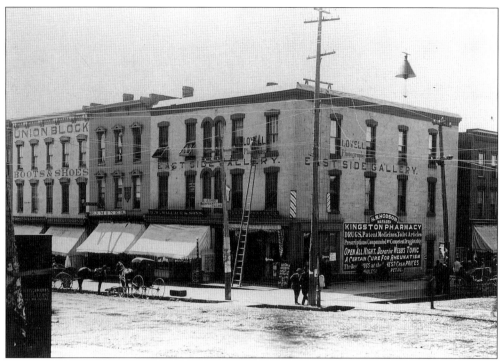

The Union Block, c. 1885. This building was on the northwest corner of East Second and Bridge Streets. Lovell's East Side Gallery was the site of many formal family portraits for decades of Oswego residents.

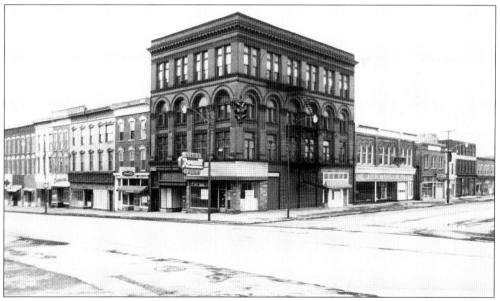

Another view of the corner of East Second and Bridge Streets, c. 1963. After a devastating fire destroyed the Lovell's Gallery building, local real estate developer Maxwell Richardson purchased the lot and built this impressive four-story commercial and office building. As with most of the east side business district, the buildings shown here were removed. Today, this is the site of the parking lot and garage for Midtown Plaza.

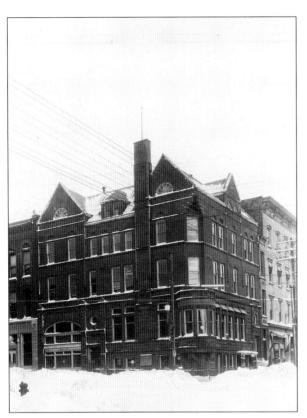

The Second National Bank, c. 1920s. This building was located at the southeast corner of East First and Bridge Streets. This is now the site of the Oswego City Savings Bank's east branch.

The southwest corner of East Second and Bridge Streets, c. 1890. Perhaps these women have been furniture or window shopping. This is the current site of the Oswego County Savings Bank.

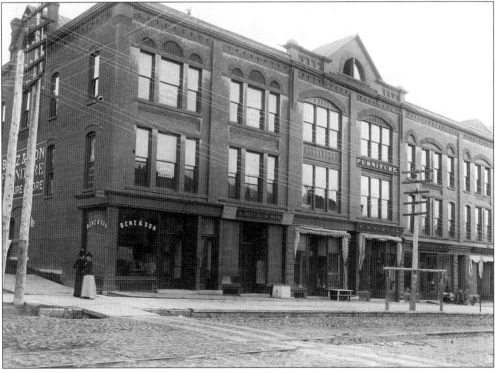

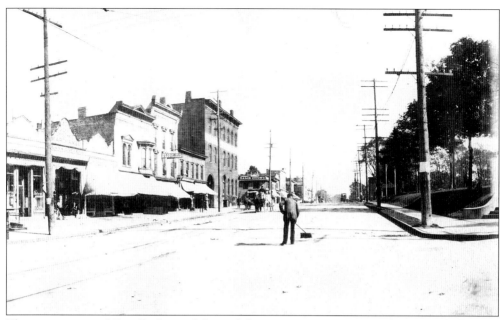

The intersection of East Bridge and Second Streets, *c.* 1906. A street cleaner works his way toward the New York Ontario & Western Depot at Third Street.

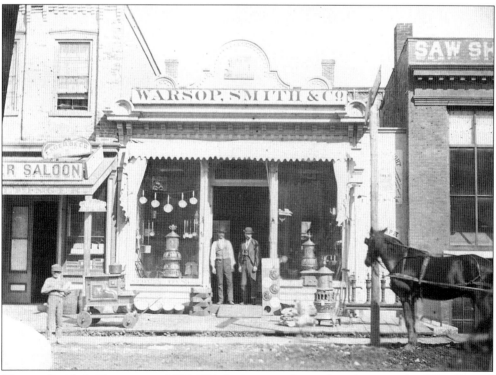

Warsop, Smith & Company, *c.* 1870. This business was located on the east side of East Second Street, between Bridge and Cayuga. They specialized in cooking and heating stoves.

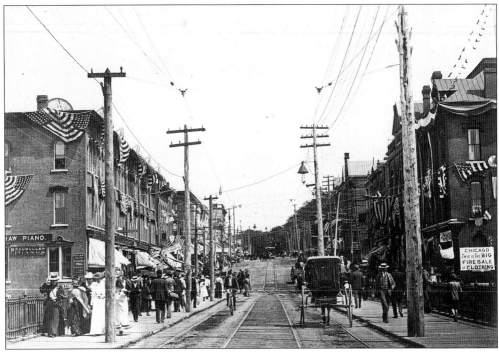

The East Bridge Street business district, *c*. 1896. Crisscrossed with electric trolley lines, telephone poles, and electric street lights, this was the center of business life for the east side of town. The brick streets offered a bumpy ride for cyclists.

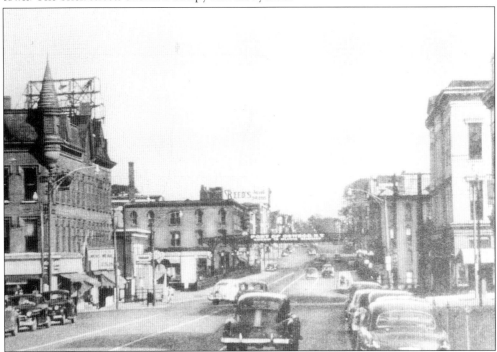

West Bridge Street looking east, *c*. 1950. Very few of the buildings in this view survived the urban renewal projects of the 1960s.

Four

Time Out

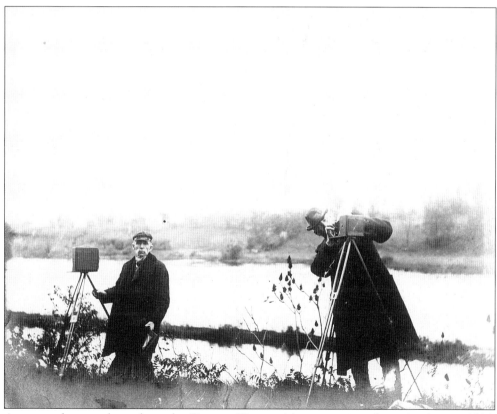

Amateur photographers along the Oswego River waiting to get just the right shot, c. 1906.
Around the time of this image, photography was fast becoming a popular recreational hobby for
a growing number of people.

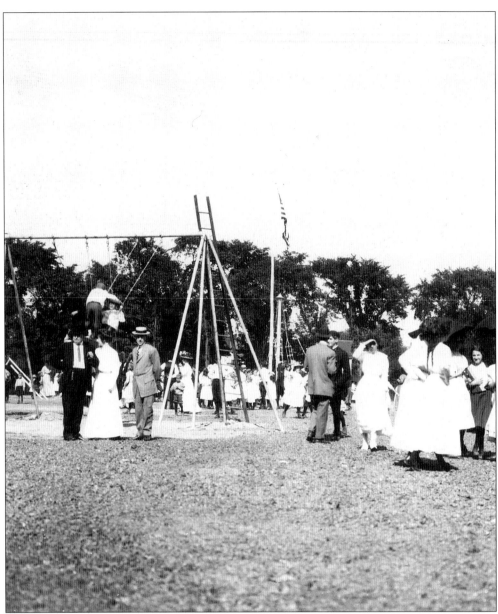

Opening day, the Kingsford Park Playground, July 31, 1909. Fueled by a national playground movement whose aim was to create natural and recreational parks within urban areas for the moral and physical benefit of children, the Oswego Municipal Playground Association was organized. The model chosen for Oswego was to be Kingsford Park in the west side of the city. The official plan encompassed 4.5 acres. It included two baseball diamonds, two basketball courts, one football field, and a running track with space for jumping pits and an area for shot put and hammer throwing. A diagonal, tree-lined walk separated these areas from the grounds for girls and younger boys. This area was outfitted with sand piles, rings, swings, teeters, and slides. At the same time, the establishment of a similar playground was proposed for Fitzhugh Park. Both of these sites would later become elementary schools.

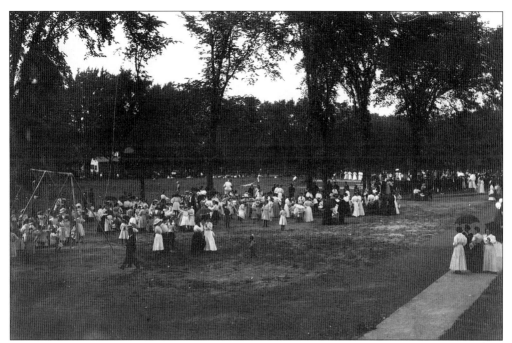

Other views of the opening day ceremonies for the Kingsford Park Playground, July 31, 1909. With tanned skin a number of years away from being fashionable, many women used umbrellas to shade themselves from the sun and heat of the afternoon.

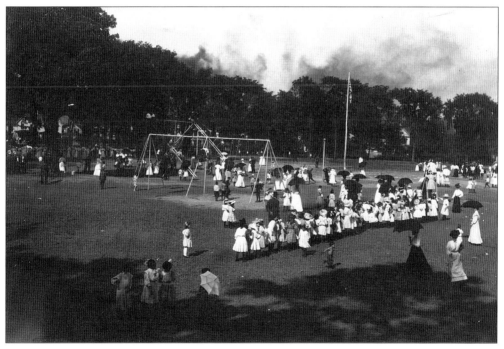

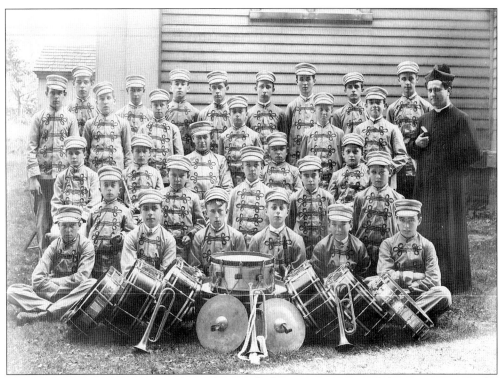

St. Peter's Drum Corps, c. 1908, shown here with their instruments and the pastor outside the church hall on East Albany Street.

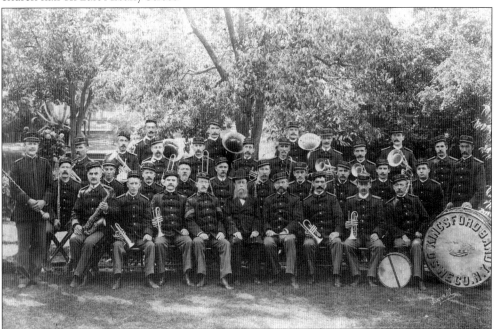

The Kingsford Band, c. 1895. Thomson Kingsford (at center) sponsored a local band with money from the Kingsford Corn Starch factory. This band entertained citizens of Oswego with outdoor concerts in the park bandstands for a number of years.

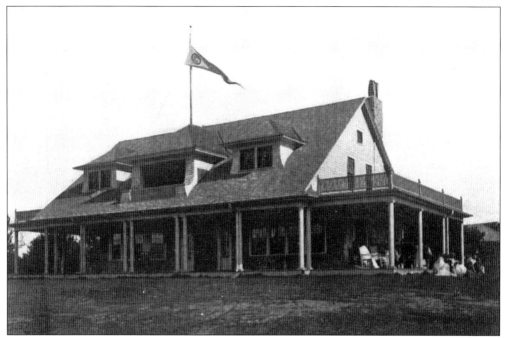

The Oswego Country Club's clubhouse, c. 1906. The Country Club organized in 1899, for "Health and the pursuit of happiness. The development of the game of Golf in Oswego, and other out-of-door recreation." They met in the former Murray Manor House—north of what is now the eighth hole. In 1903, they constructed their own clubhouse at the southeast edge of their property. Additions to this building were completed in 1994.

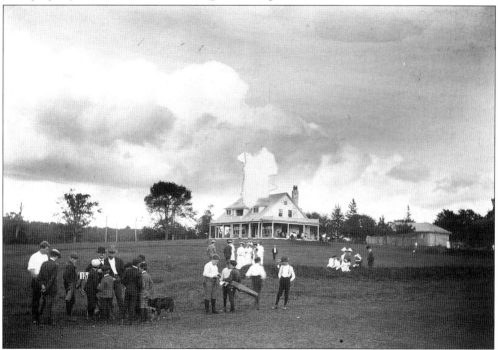

Lowering clouds seem to threaten a golf outing at the Country Club, c. 1903.

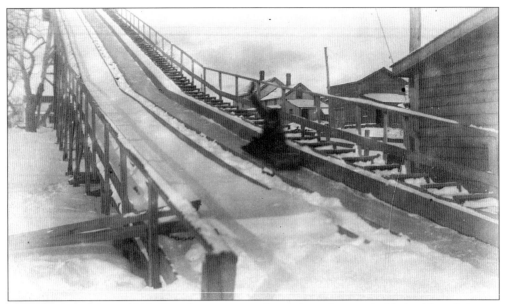

The toboggan slide, *c.* 1888. Traveling not quite faster than the speed of light (though it may have felt like it), the blur is actually a youngster on his sled hurtling down a slide built at Hillside Avenue and West Bridge Street.

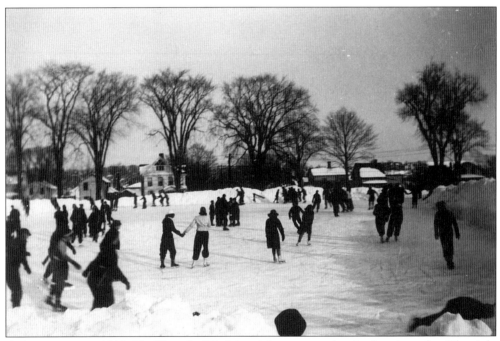

A skating party, *c.* 1941. The Kingsford Park ice rink was a popular site for winter fun. The rink, at West Fifth and Niagara Streets, was enclosed and renamed the James P. Cullinan Jr. Ice Rink in 1967.

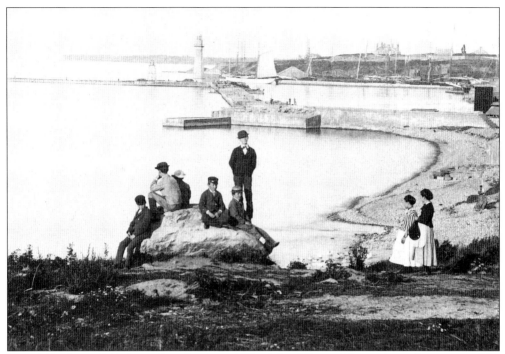

Lover's Rock, *c.* 1880, located at the foot of West Third Street. The rock was later covered by the building of the Delaware, Lackawanna, and Western Railroad's coal trestle in 1883. The trestle itself was removed in the 1940s.

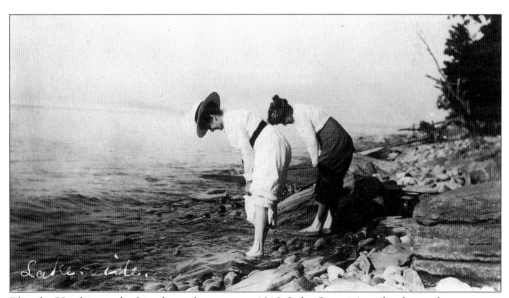

Blanche Hawkins and a friend test the water, *c.* 1910. Lake Ontario's rocky shore often serves as a magnet to overheated feet during the summer months.

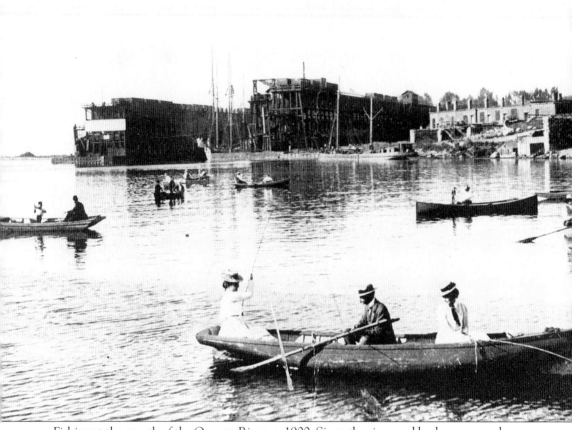

Fishing at the mouth of the Oswego River, *c.* 1900. Since the river and harbor were no longer so heavily used by commercial vessels, it left the channel safe for recreational boaters to try their hand at fishing. Here, one female angler is very successful.

Family picnic, c. 1885. Even after the coal trestle obstructed most of the view, this area remained a popular spot for an afternoon's entertainment.

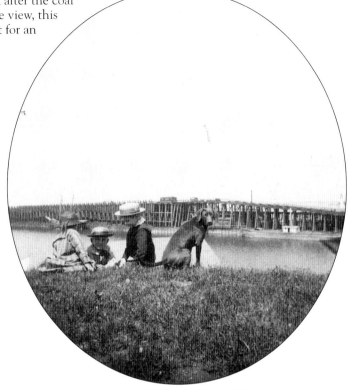

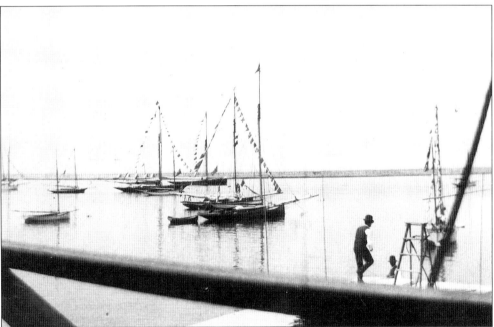

Preparing for a race, c. 1889. These men are apparently getting ready for one of the many yacht races sponsored by the Oswego Yacht Club. The construction of the breakwater in the west harbor offered them refuge from lake storms.

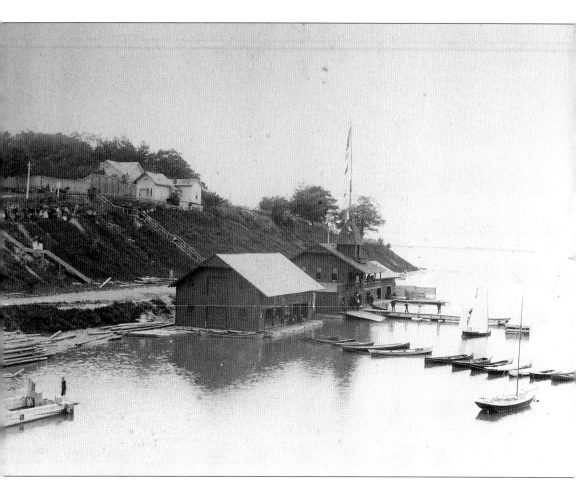

The Oswego Yacht Club, *c.* 1890. Founded in 1883 by a handful of Oswego's wealthier citizens, the Yacht Club was able to build a substantial new boathouse (at left) just four years later. By the turn of the century, the club boasted around two hundred members and a fleet of twelve sailing yachts and five steam yachts. The numerous Mosquito craft in the marina reflect the apparent interest of Oswego's middle class in water recreation, and their inclusion in the club's membership. During the 1920s, a substantial new clubhouse was built on the bluff above the one seen here. The Oswego Yacht Club is still an active organization.

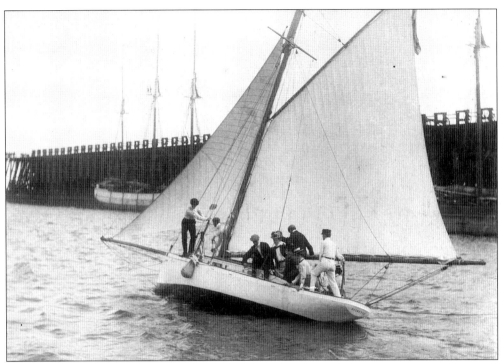

On board the sloop-rig yacht *Velnette* in Oswego harbor, *c.* 1898. Helping out owner Henry Sayward are Margie Shear, Lydia Lyman, R. Cole, L. Failing, L. Cole, N. Failing, E.W. Lyon, George Hayward, and E.A. Sayward.

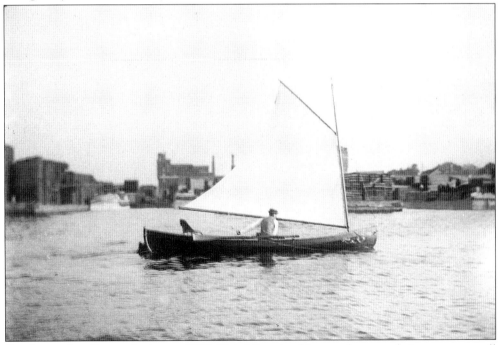

Out for a sail in Oswego harbor, *c.* 1892. This fellow is taking no chances—he's got oars as well as a sail in this Mosquito boat.

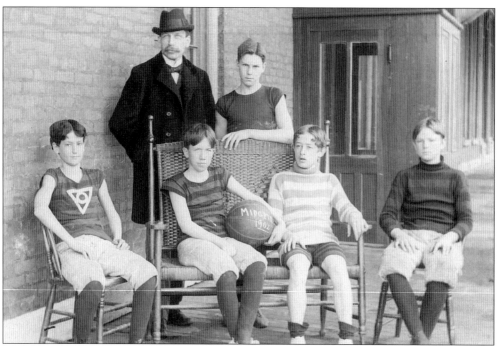

The 1902 Oswego YMCA Midgets basketball team rests between games.

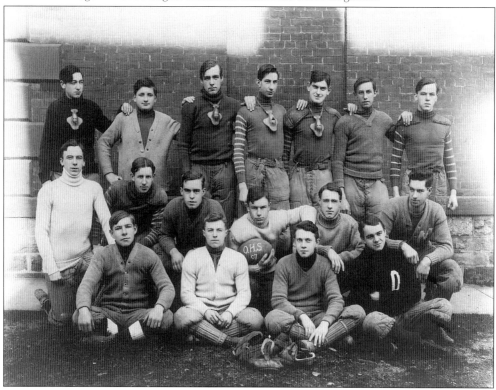

The Oswego High School football team, c. 1907. Advances in player protection have made these intrepid fellows' pads seem ludicrous in comparison to those of today.

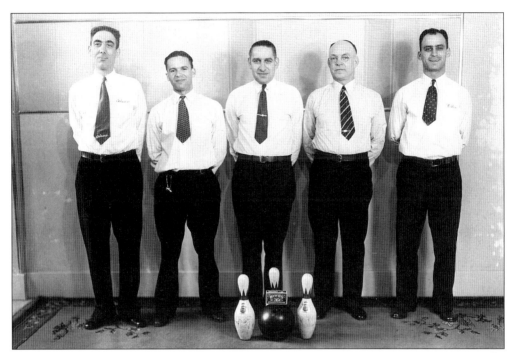

Bowling champions, *c.* 1938. The Diamond Match Company's Birds Eye team poses for the camera. John "Nag" Demore (second from left) was eventually inducted into the Oswego Bowling Hall of Fame.

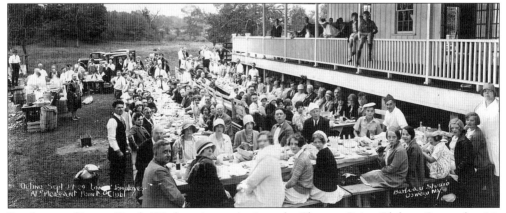

Employees of Longs Candy Works enjoy a picnic at the Pleasant Point Club on September 14, 1929. This was probably part of the Labor Day festivities for employees and their families.

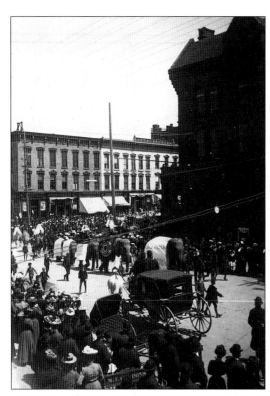

A circus parade, *c.* 1900. Elephants lead the parade along East First and Bridge Streets to alert the young and young at heart of its presence.

Another circus parade, *c.* 1905. Caged kings of the jungle move along East Bridge Street between Second and First on their way across the bridge. Judging from the bicycle riders in this view, the bicycle shop behind the wagon was doing a good business.

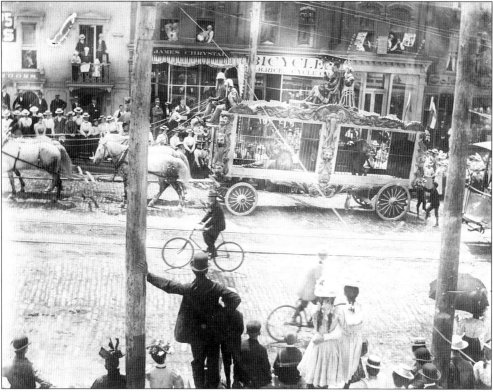

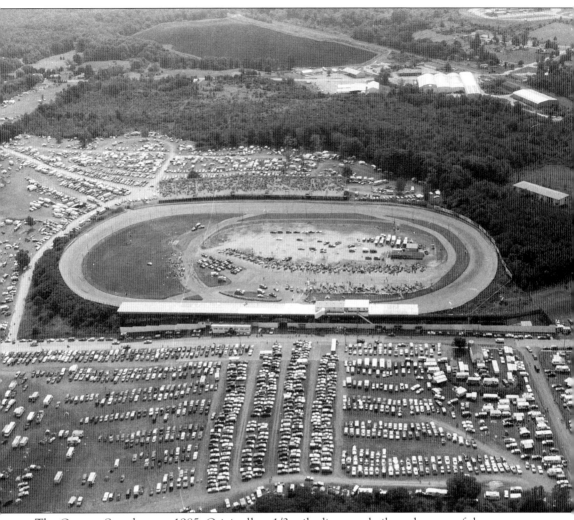

The Oswego Speedway, c. 1985. Originally a 1/3 mile dirt tract built at the turn of the century for horse racing, it was abandoned in the 1930s. In 1950, George and Harry Caruso purchased the site and established the Oswego Speedway in August of 1951. The following year, they paved the dirt track, and in 1961 the track was expanded to its present size—the old 1/3 mile track is now the entrance to the pit area. The spectator's bleachers have also expanded over the years; with a capacity of about three thousand fans in the early years, they accommodate over ten thousand today.

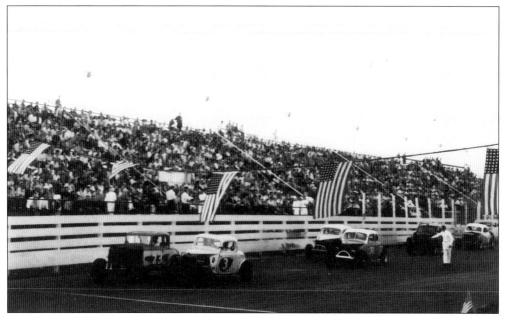

The Oswego Speedway, c. 1959. These early cars would eventually make way for the supermodified cars currently burning up the tract and entertaining race enthusiasts throughout the Northeast and Canada.

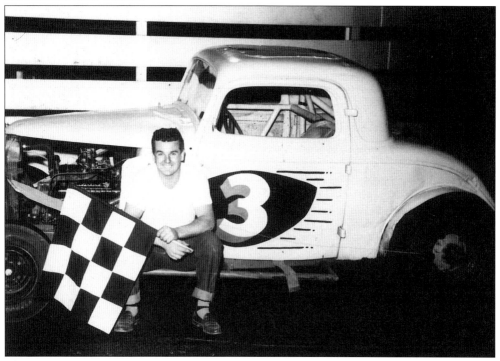

The Oswego Speedway, c. 1959. Ed Bellinger Sr. of Fulton, New York, in car #3, thrilled race fans throughout the early years of the speedway driving class A and B racers. In 1972, his son, Ed Jr., took the track in a supermodified class car, continuing in his father's footsteps by thrilling today's race fans.

Five

Built for Comfort

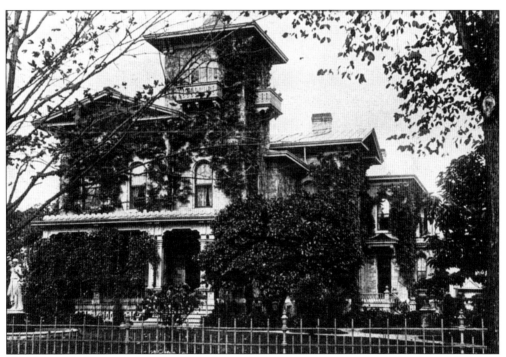

The George B. Sloan residence, c. 1870. Oswego's prominence as a commercial and manufacturing community during the last half of the nineteenth century is reflected in the number of stately homes built for mill owners, shipping agents, and real estate developers. The economic decline that followed is evidenced by the lack of "great" homes from the beginning of this century. As with many of the large homes from the past, the only way some could survive was through conversion to multiple family dwellings. Such is the case with the Sloan residence.

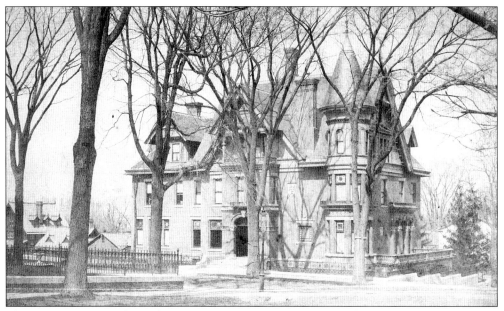

The Henry Swits Condé residence, Mon Repos, *c.* 1883. The Condé's stately mansion stood at the northeast corner of West Fifth and Seneca Streets. Built for the owner of the largest textile mill in the city, this house would be razed shortly after his death and replaced with a number of more modest homes.

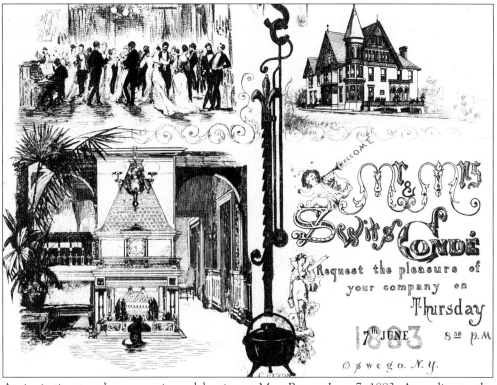

An invitation to a housewarming celebration at Mon Repos, June 7, 1883. According to the local newspaper account, no expense was spared for the festivities or the home's furnishings.

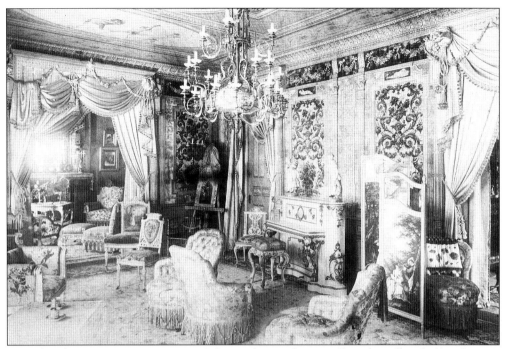

Formal parlors, Mon Repos, *c*. 1883. Gilt grandeur and more silk and scrollwork than Oswego had ever seen filled entire rooms at Mon Repos. The upper class in Oswego could afford to live in luxury.

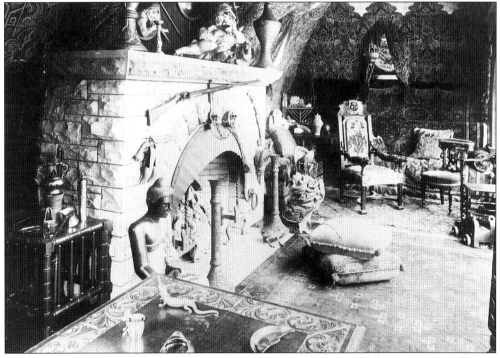

Turkish corner, Mon Repos, *c*. 1883. The "oriental" or "Turkish" style had a very strong influence on American interior furnishings in the late nineteenth century.

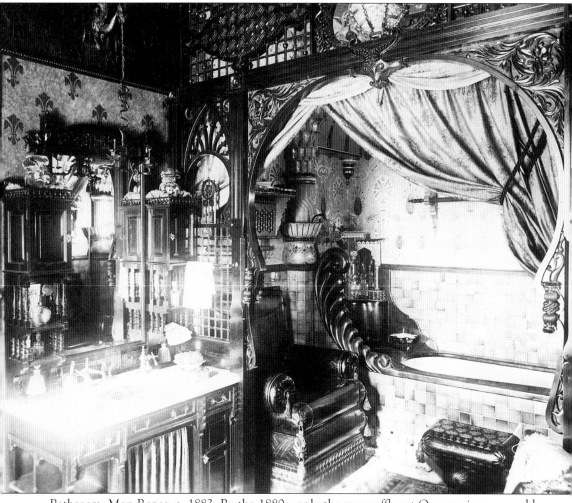

Bathroom, Mon Repos, c. 1883. By the 1880s, only the more affluent Oswegonians were able to include at least one full bathroom in their homes. Here again it seems that Mr. Condé took consumerism to a lofty level—the disguised water closet (toilet) is located between the sink and bathtub. Apparently, Mr. Condé liked the dragon sconce above the sink, as it reportedly also appeared in his apartments in New York City.

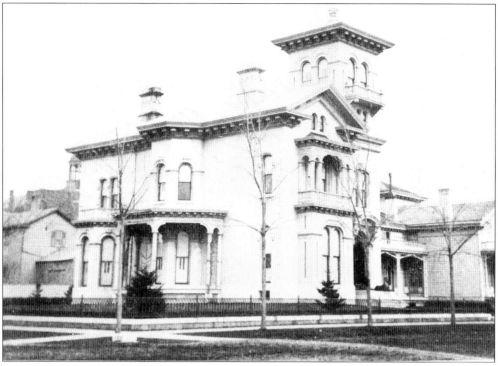

The Maxwell Bennett Richardson residence, *c.* 1872. Built for Maxwell Richardson, attorney, real estate developer, and mayor, this home reflects the means and tastes of an upper-middle-class family at the time of its construction. Maxwell, a bachelor, shared his home with his widowed mother Naomi, his brother Lawrence, his divorced sister Harriet, and Harriet's son Norman Bates.

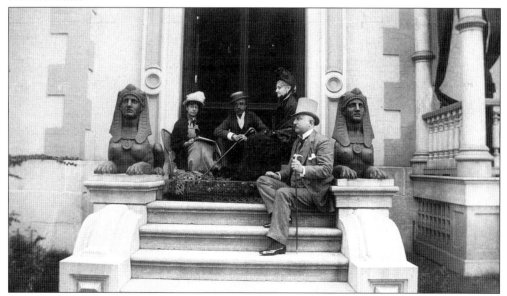

Another view of the Maxwell B. Richardson residence, August 23, 1889. Flanked by their guardian sphinxes, the family poses for the camera. Naomi Richardson noted in her diary that "Norman took Max, Lawrence, Hattie and my picture when we sit on the steps this morning."

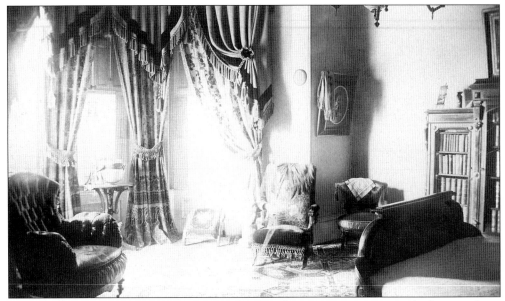

Harriet Richardson-Bates' bedroom, the Richardson home, *c.* 1888. Harriet's bedroom reflects 1870s tastes, with the use of heavy curtains and drapery with lots of trim and tassels. Notice the partially visible male figure in the chair—exposure time took considerably longer than that of today, and moving out of position too soon often created ghostly images.

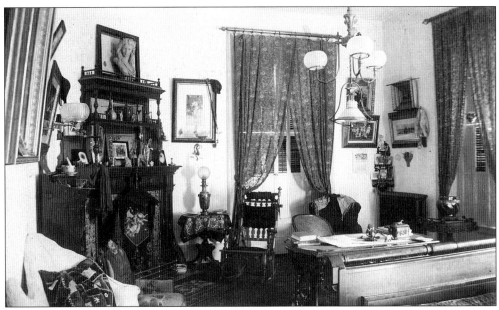

Norman Bates' bedroom, the Richardson residence, *c.* 1889. Notice the simple lace curtains in the windows. Norman's curtains, unlike those of his sister, were easy to keep clean; at the time, it was believed that this encouraged a healthy environment.

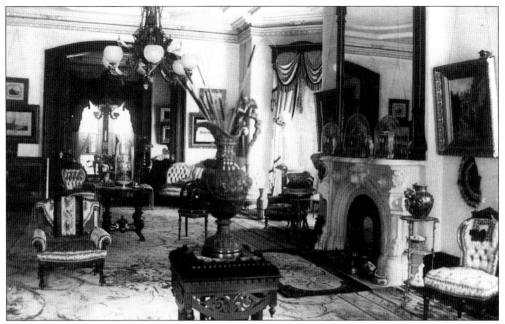

Formal drawing room, the Richardson residence, c. 1889. Befitting an upper-middle-class family, the Richardsons appear to have followed the decorating advice published in many journals of the period. The authors of these articles recommended that the home-owner spend the bulk of their furnishing budget outfitting the formal parlors with the finest furniture, carpets, and draperies available. This room is still not on the level of a family as wealthy as the Condé family (see p. 83).

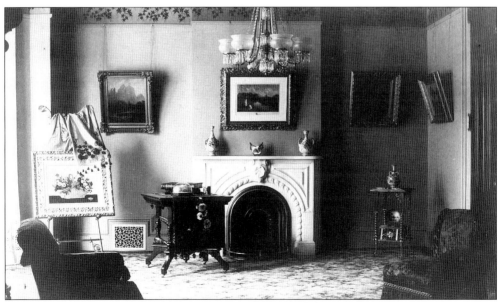

Parlor, the Richard J. Oliphant residence, c. 1890. While not as richly appointed as the Richardson's drawing room (above,) the enameled vent cover to the right of the fireplace indicates they were still able to afford a central heating system for their home.

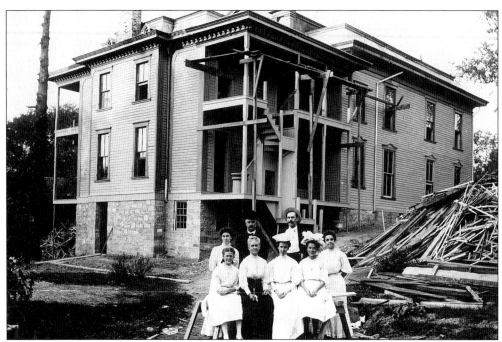

The apartment house (rear elevation) at 146 East Sixth Street, c. 1907. At the turn of the century, increased demand for goods produced in Oswego's textile mills lead to mill expansion, and a larger work force. This, in turn, lead to a need for additional housing to accommodate the growing number of mill workers. This single family home, in a historically middle-class neighborhood, was converted into apartments for these employees of the Minetto Shade Cloth factory.

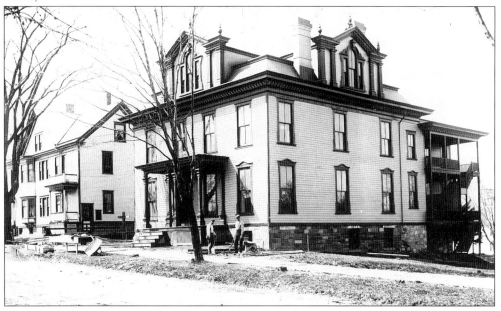

The apartment house (front elevation) at 146 East Sixth Street, c. 1907. The facade changed very little after conversion. Interestingly, the manager and co-owner of another textile mill lived in a substantial home across the street from this apartment house.

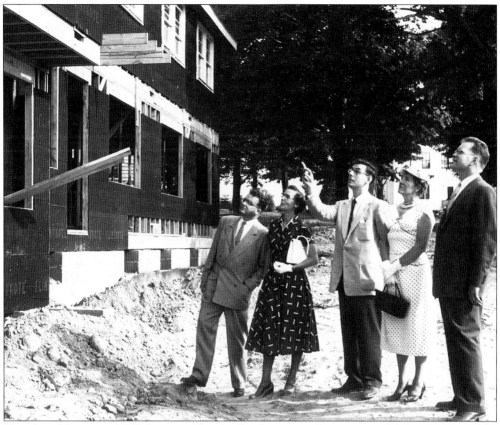

Hamilton Homes, *c.* 1955. State and local officials inspect the progress of Oswego's first public housing development. From left to right are Joseph McMurray, Dorothy Mott, John Fitzgibbons, Marian Mackin, and Arthur Reed.

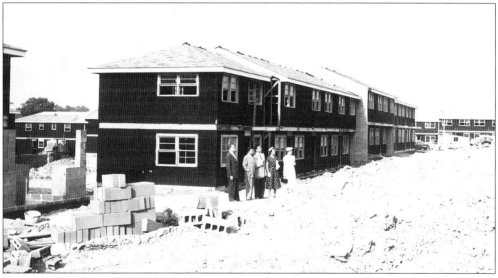

Hamilton Homes, *c.* 1955. The Oswego Housing Authority remained involved in every phase of construction.

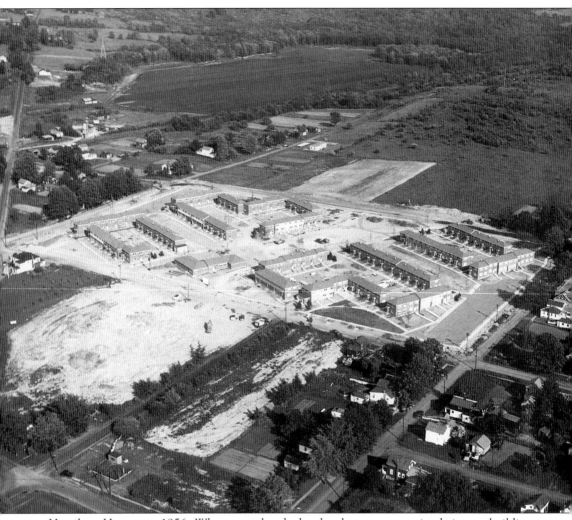

Hamilton Homes, c. 1956. When completed, the development contained sixteen buildings, with a total of 116 apartment units. Within a year after completion, all units were full and the Housing Authority had a waiting list of over 125 families. Shortly after it opened the Hamilton Homes development, members of the Housing Authority were approached about developing a similar project for senior citizens' housing.

Six

Faces from the Past

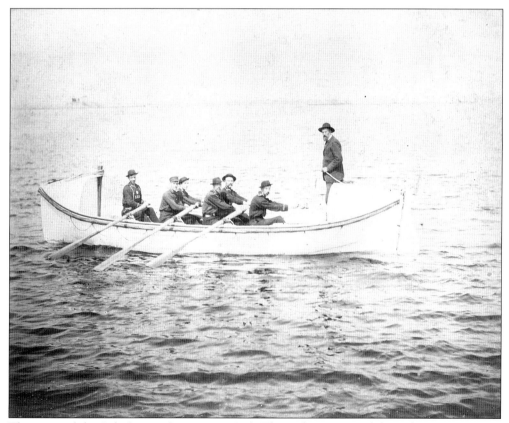

The crew of the Life Saving Station, *c.* 1875. The stalwart men of the Life Saving Station demonstrate the effectiveness of their boat. At the time the Life Saving Station was located on the banks below Fort Ontario.

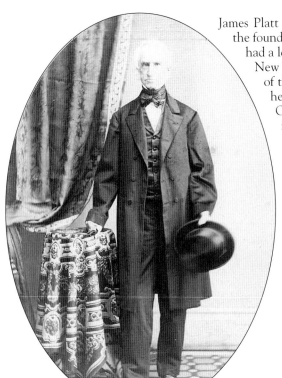

James Platt (1788–1870), *c.* 1869. A descendant of the founding family of Plattsburg, New York, James had a long and illustrious political life in upstate New York. In addition to being the first mayor of the incorporated City of Oswego in 1848, he was twice president of the Village of Oswego and served as our representative in the New York Senate in 1852.

Alvin Bronson (1783–1881), *c.* 1830. Mr. Bronson played an unparalleled role in Oswego's early history. In 1810, he came to Oswego to oversee his Great Lakes shipping business. During the War of 1812, Bronson was made keeper of the naval supplies and was taken prisoner by the British in the Oswego Battle in May of 1814. In 1828, he was honored with election as the first president of the Village of Oswego.

Maxwell Bennett Richardson (1838–1903), *c.* 1880s. Lawyer, real estate developer, insurance agent, and twice mayor of Oswego (1867 and 1883), Max Richardson was involved in all aspects of the community. He promoted the idea of a paid professional fire department, helped develop trolley service in the city, owned one of the nicest theaters in the city, and gave generously to numerous community benefit organizations. Mr. Richardson was also a founding member of the Oswego County Historical Society in 1896. His residence is now the headquarters of the Society–a gift from the children of his nephew Norman Bates in 1946.

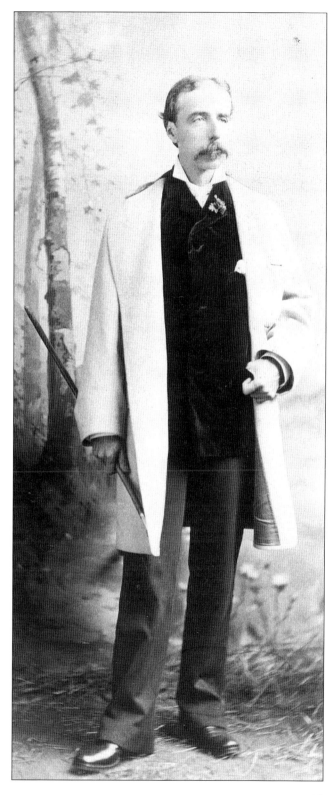

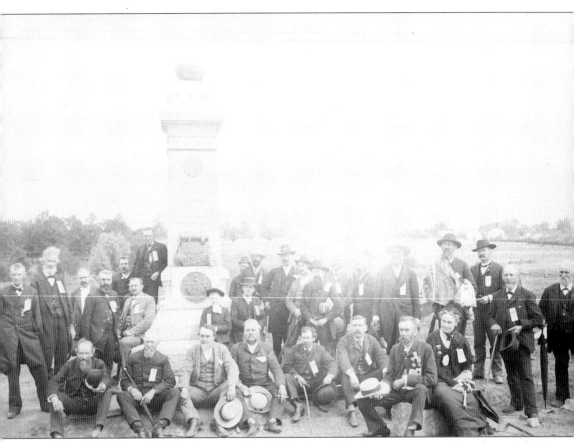

The 147th New York Regiment at the dedication of their monument at Gettysburg, July 1, 1893. This regiment took part in the opening of the decisive battle which marked the turning of the tide in the Civil War. At a cost of 72 casualties and 144 seriously wounded, they delayed Lee's advance division. The Oswego Regiment's veterans attempted to make annual pilgrimages to Gettysburg after the monument dedication. This is the only view of the 147th we are aware of. Mrs. Elmina Spencer (front right) was a nurse traveling with her husband, who served with the 147th.

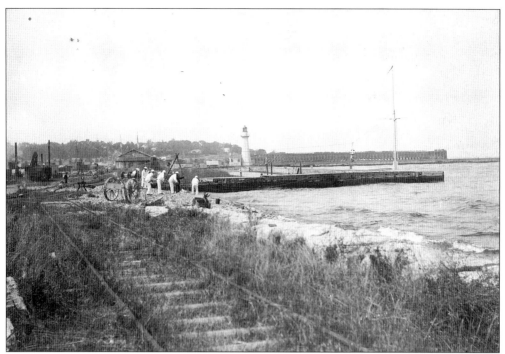

Oswego harbor, *c.* 1896. The Coast Guard is testing one of the life saving harnesses used to remove people from sinking ships. Notice the man coming down the rope slightly to the left of center.

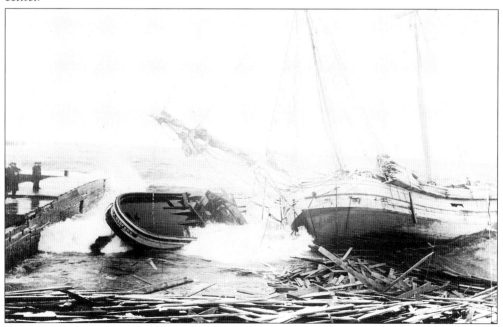

The wrecks of the tug *Eliza Redford* and the schooner *Flora Emma*, November 15, 1893. The action of wind and wave often drove sailing ships aground on the shoals just east of the harbor. The Coast Guardsmen helped rescue the crew from these ships. The cargo of lumber was probably salvaged as well.

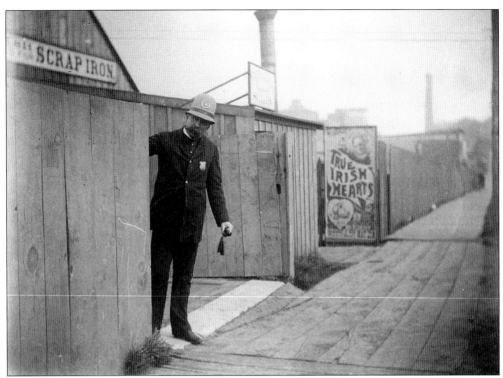

Policeman on the beat, *c.* 1890. Here we find one of "Oswego's finest" keeping the peace.

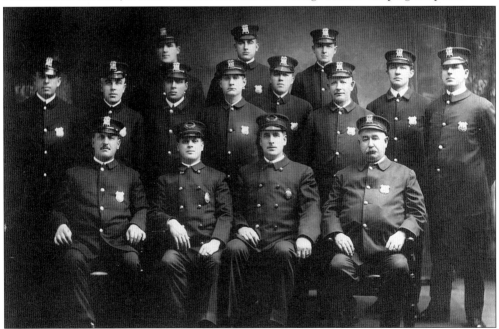

Oswego Policemen, *c.* 1935. Oswego's police department began in 1828, with the appointment of two constables—one for each side of the city. The force grew steadily, and by 1870 there were sixteen members. By 1995, they were under the command of the city's first female police chief, Kathleen MacPherson.

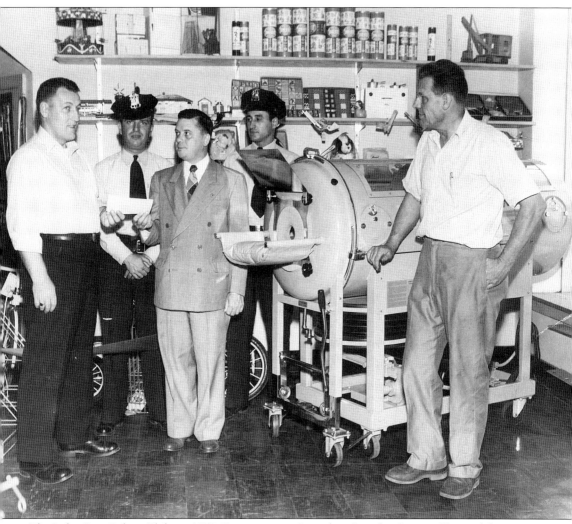

The Lake City Police Club, *c.* 1951. Presenting an "iron lung" to the Oswego Hospital for use with polio victims are Jack Smith, John Conzone, Frank Molonari, John Galetta, and Francis Peters. The club has always done its part to protect and serve the residents of Oswego.

Edward Austin Sheldon (1823–1897), *c.* 1875. Sheldon, an educator and educational theorist, founded the Oswego Normal School to help train teachers. It eventually grew into the present multi-disciplinary State University of New York College at Oswego.

Louis J. Lavonier (1852–1934), *c.* 1890. A craftsman and cabinetmaker, Mr. Lavonier would include among his projects the library and dining room in the residence of Maxwell Richardson as well as furniture for Mr. Richardson. A number of other homes in Oswego boast the artistic and technical skill of this remarkable person.

Elmina Spencer (1819–1912), September 15, 1898. Mrs. Spencer served as a nurse during the Civil War, following her husband and the 147th New York Regiment into battle. In this portrait, she is wearing a number of ribbons and medals from various Civil War veterans' reunions.

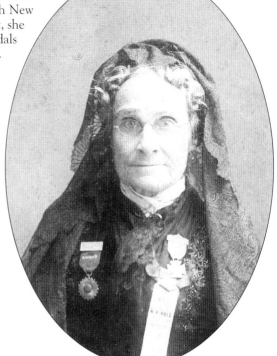

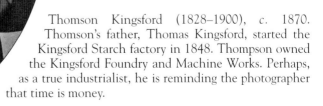

Thomson Kingsford (1828–1900), c. 1870. Thomson's father, Thomas Kingsford, started the Kingsford Starch factory in 1848. Thompson owned the Kingsford Foundry and Machine Works. Perhaps, as a true industrialist, he is reminding the photographer that time is money.

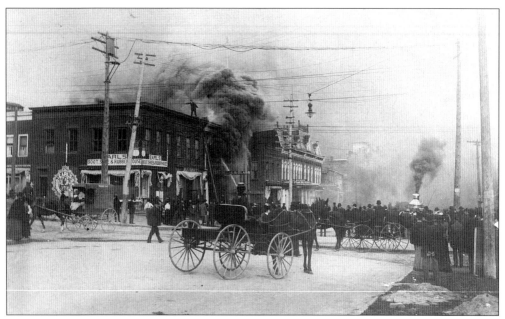

The Oswego Fire Department rushes to the rescue, 1897. This frequently reproduced image is of the fire at Aaron Colnan's paint shop, 124 West Second Street. Advances in fire prevention and fire fighting equipment have not made the job of the dedicated firefighters any less dangerous.

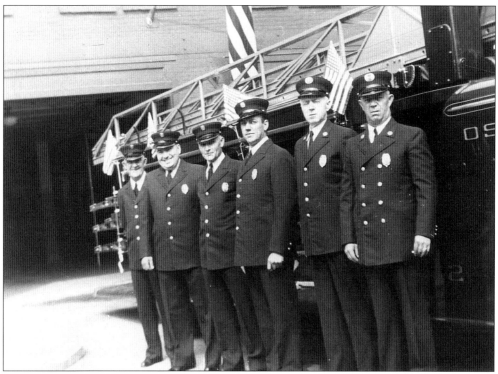

The Oswego Fire Department, c. 1940s. The dedicated crew of Hook and Ladder #2 pose outside their station with their equipment. Captain Frank Boardman is on the far right.

Ready for action, *c.* 1923. Members of two west side fire companies try out their new ladder truck along West Second Street between Bridge and Cayuga Streets. When this photograph was taken, motorized firefighting vehicles were still fairly new to Oswego. In fact, it had taken until 1917 for the city to purchase its first. Pictured here are A. Wise, Frank Boardway, Laurence Dashnau, and Joseph Shurr.

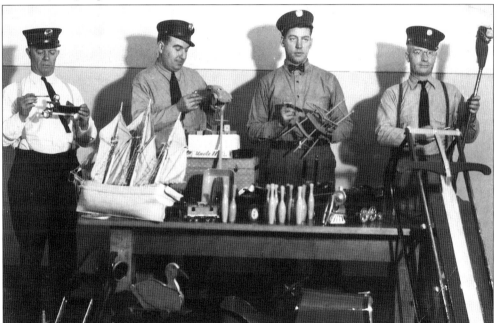

Oswego Fire Department members repair toys for donations to local charities at Christmas, *c.* 1940. Pictured from left to right are Captain Frank Boardman, Theo McCarthy, Charlie Leonard, and Harry Devans.

William C. Raulston, c. 1863. William was a captain in Company A of the 81st New York Regiment, and a colonel in the 24th New York Cavalry. He was taken prisoner on September 29, 1864, and was shot while leading an escape attempt from Dansville Prison.

Dr. Mary E. Walker (1832–1919), c. 1906. Mary Walker was born and raised in Oswego Town. In her time she became a national figure, representing the efforts of nineteenth-century American women to explore new roles. As acting assistant surgeon with the U.S. Army during the Civil War, she became the only woman to be awarded the Medal of Honor. As an advocate of women's rights, she became especially well known for her efforts on behalf of dress reform.

An unknown mail carrier, *c.* 1900. In the realm of public service, sometimes it is the small acts of bravery which count, such as the courage needed to deliver mail in the midst of an Oswego blizzard. As part of Oswego's Old Home Week celebration in 1906, the New York State Letter Carriers held their annual convention here.

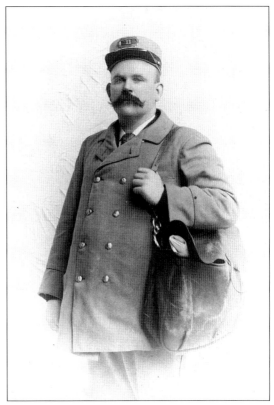

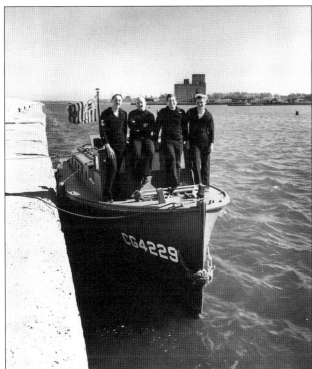

Coast Guardsmen, *c.* 1940s. On December 4, 1942, a tragic accident claimed the lives of six Coast Guardsmen stationed here when they attempted to change shifts at the lighthouse. Shortly after the accident, the lighthouse was automated.

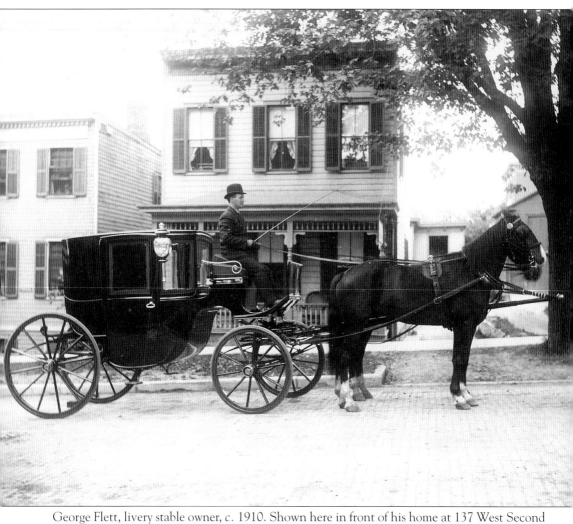

George Flett, livery stable owner, *c.* 1910. Shown here in front of his home at 137 West Second Street, his stables were located at 104 West Second Street until 1915. The brick streets of Oswego once rang to the iron shoe of livery horses conveying people here and there. Today, the Centro Buses serve many of the same routes Mr. Flett may have covered.

Seven

Strike Up the Band

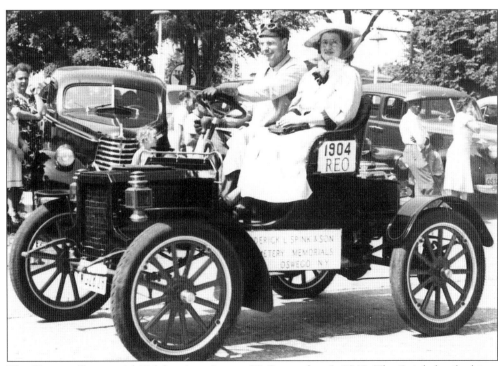

The Oswego Centennial Celebration, August 29–September 6, 1948. The Spink family drives their entry through the parade: a nifty 1904 REO.

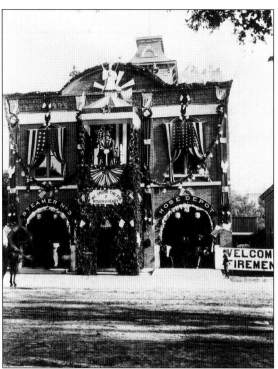

Fire company #3 at East Bridge and Sixth Streets, August 1894. Oswego played host to the New York State Firemens' Convention. Here, the fire house is all decorated for the occasion. The company moved to East Cayuga Street in the 1980s, when the building could no longer accommodate the modern equipment.

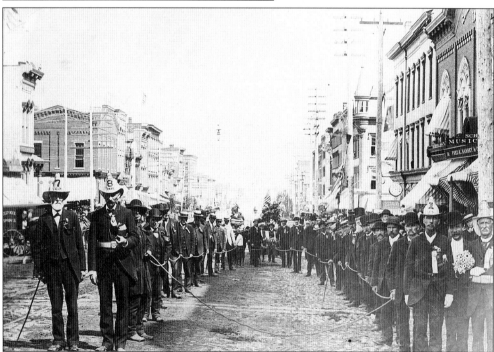

The Firemen's Convention, August 1894. Firemen from various state companies, both active and retired, line West First Street between Oneida and Bridge Streets. Activities during the convention, which lasted several days, included demonstrations and competitions for the public.

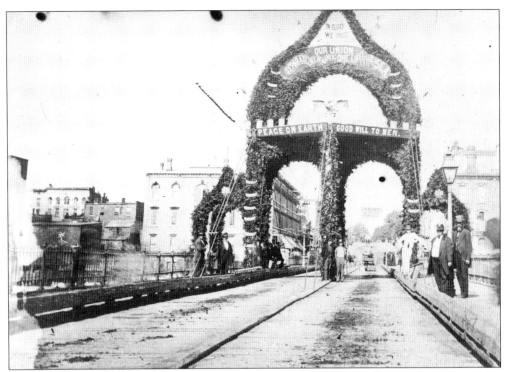

The Bridge Street bridge, July 1876. The arch on the bridge was decorated as part of the festivities throughout the city in celebration of the country's 100th birthday.

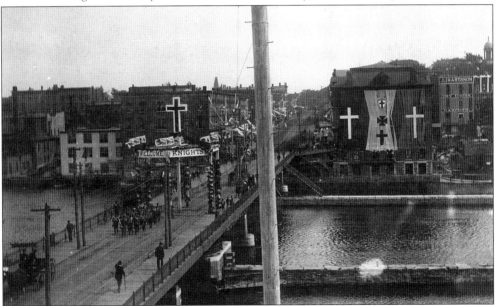

The Bridge Street bridge, c. 1889. The giant banners draping the buildings along the river and welcome signs on the bridge help celebrate a convention of the Knights of Pythias in Oswego. At one time, Oswego boasted a large number of lodges and societies. In addition to the Knights of Pythias, the Odd Fellows, Knights of Columbus, Eagles, Red Men, and numerous Masonic orders had lodges in Oswego.

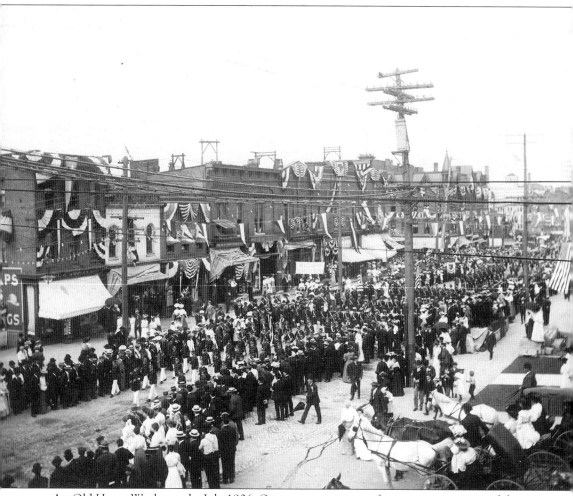

An Old Home Week parade, July 1906. Oswego was just one of many communities celebrating Old Home Week in 1906. There were parades, pageants, and concerts. Most of the city turned out to watch the parade on West Bridge Street.

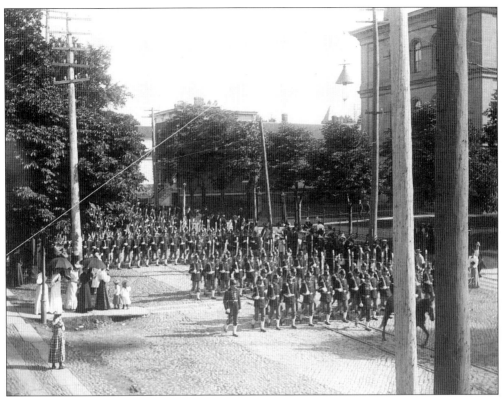

Another view of the Old Home Week parade, July 1906. The regarrisoning of Fort Ontario played a major part in this week-long celebration.

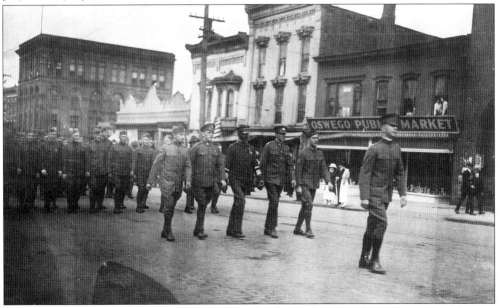

George D. Cronan leads veterans down East Bridge Street, between Second and Third Streets, c. 1919. Veterans of every war have marched in Memorial Day, Fourth of July, and Labor Day parades.

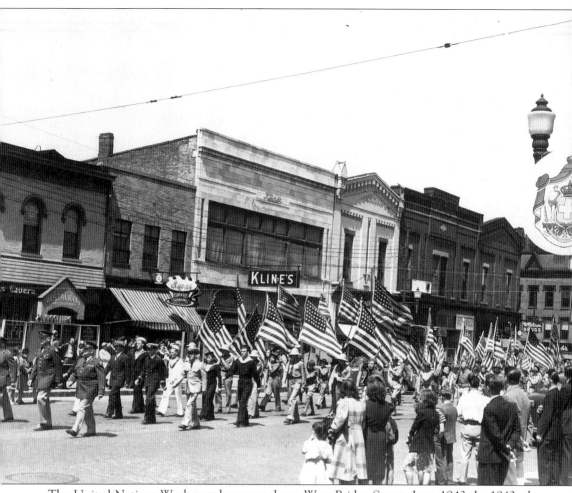

The United Nations Week parade moves down West Bridge Street, June 1943. In 1943, the United States Office of War Information decided that Oswego was an archetypical American city and the perfect place to stage "United Nations Week." It was a chance to introduce average Americans to their European (and other) allies. There were speeches by officials, awards to defense workers, tours of the factories, displays in the shop windows, kiosks about allied countries set up around town, a carnival, and of course, this parade.

The United Nations Week carnival, June 1943. A Belgian sailor helps a local youngster prepare for an exciting airplane ride.

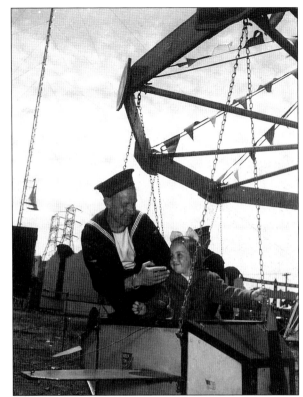

The United Nations Week carnival, June 1943. Members of several branches of the service mingle with the locals. This was an opportunity for the allied servicemen to experience small-town America.

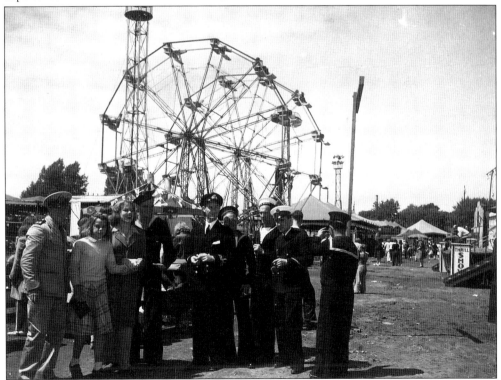

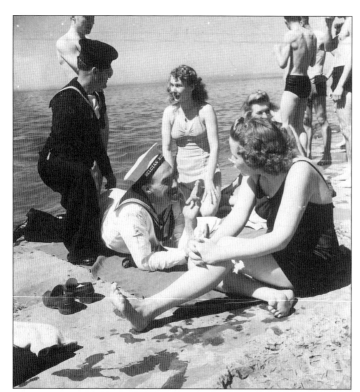

United Nations Week, June 1943. Sailors from several countries enjoy conversation and swimming along Lake Ontario's shore with some new friends.

United Nations Week, June 1943. Soldiers line up for coffee and refreshments in between dancing or mingling. The USO poster on the wall serves as a reminder that hometown support for the troops went on beyond this one event.

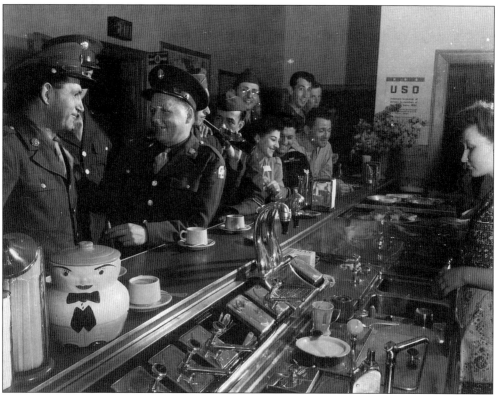

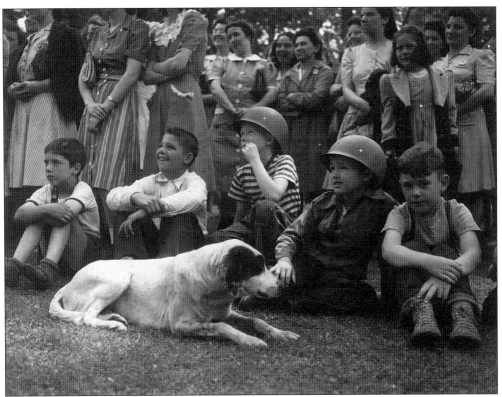

United Nations Week, June 1943. Even the family dog participated in the United Nations Week activities. Factory workers were sometimes let out early and urged to attend the rallies and speeches. Even the children participated in the war effort.

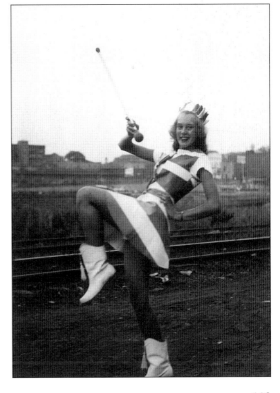

A majorette demonstrates a high step for the camera at Oswego's week-long centennial celebration, August 29–September 6, 1948.

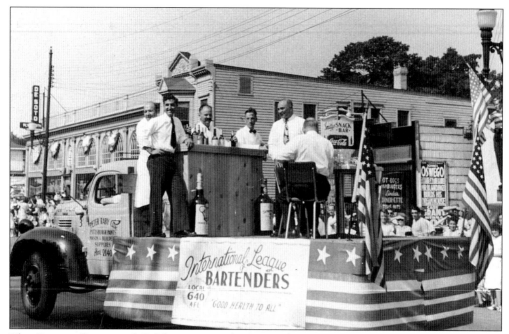

The Oswego Centennial Celebration parade, September 1948. Local bartenders organized and entered their float in the Labor Day parade. Here they prepare to spread some cheer along East Bridge Street. The week-long celebration included pageants, concerts, baby parades, and historical reenactments. Everyone was welcome to participate, and hundreds did.

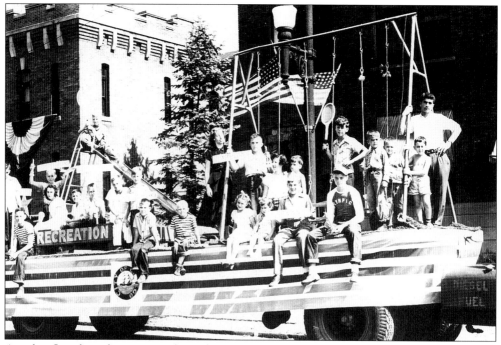

Another float from the centennial parade, September 1948. Local children pose with playground equipment and in Little League uniforms as the "Recreation" float passes by the Armory building along West First Street.

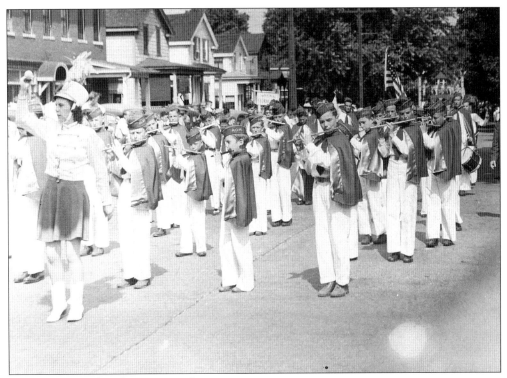

A marching band in the centennial parade, September 1948. Organizations and marching bands came from all over central New York to help Oswego celebrate its centennial. Here, an Ancient Order of Hibernians band from Syracuse prepares to turn from East Seventh onto Bridge Street.

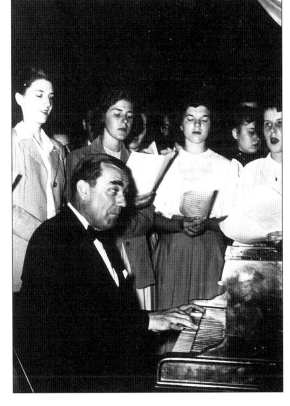

Rehearsal for the Sacred Concert, September 1948. Charles Davis accompanies singers during the rehearsal for the Sacred Concert. At left is Jean Smith Burns and at the extreme right is Julie Fitzgibbons Sullivan.

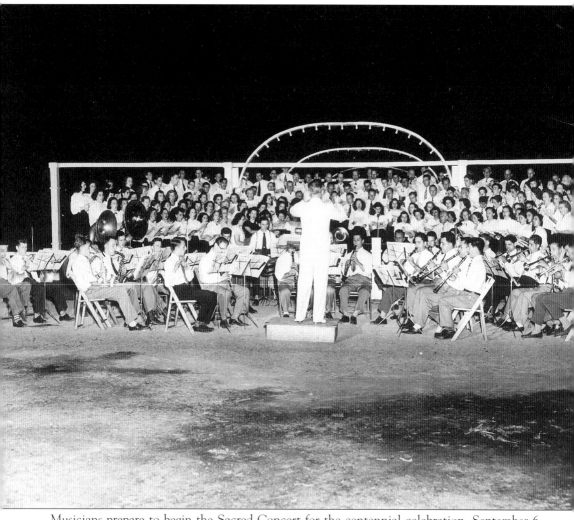

Musicians prepare to begin the Sacred Concert for the centennial celebration, September 6, 1948. For the Sacred Concert, local choirs rehearsed at their home churches and then were brought together with the all-city band under the direction of Weldon Grose. The concert was held at a site along West First Street.

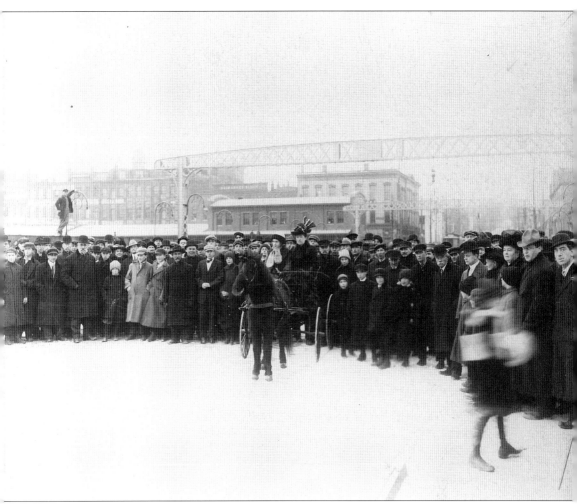

The Bridge Street bridge, December 18, 1911. The opening of the new bridge was hailed by a throng of Oswegonians. Riding in the pony cart with the wife of Mayor John Fitzgibbons is young Verna Chetney. The bridge was replaced in 1968.

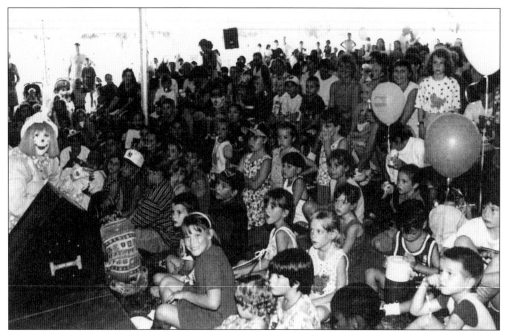

The Oswego Harborfest, c. July 1993. A clown entertains children and adults alike during the Harborfest celebration. Held during the last weekend in July, the festival celebrates the harbor with music, historical reenactments, crafts, and demonstrations. One evening of the celebration features a spectacular fireworks display above the harbor to an appreciative crowd of thousands of spectators.

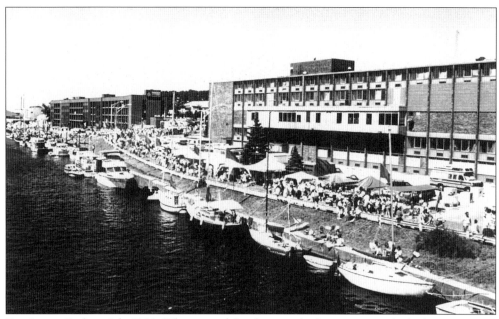

East Linear Park, c. July 1991. Where canal freighters and schooners once docked next to grain elevators over one hundred years ago, pleasure boats now tie up behind hotels in preparation for another Harborfest celebration.

Eight

The Three R's

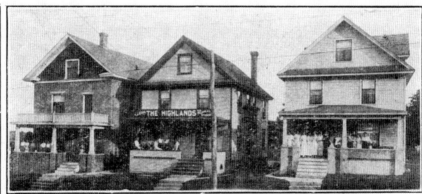

Room and Board in These Beautiful Homes

For lady students attending the State Normal School at Oswego, N. Y.
Located across the street in front of the school. Rates reasonable.

F. A. COON.

Student boarding houses, Washington Boulevard, *c.* 1918. These houses provided gender-specific housing prior to the building of dormitories on campus. In many ways, education has helped make Oswego. In 1867, Edward Sheldon (see p. 98) founded the Normal School for the purpose of training teachers. Now, as the State University of New York College at Oswego, it teaches some eight thousand students.

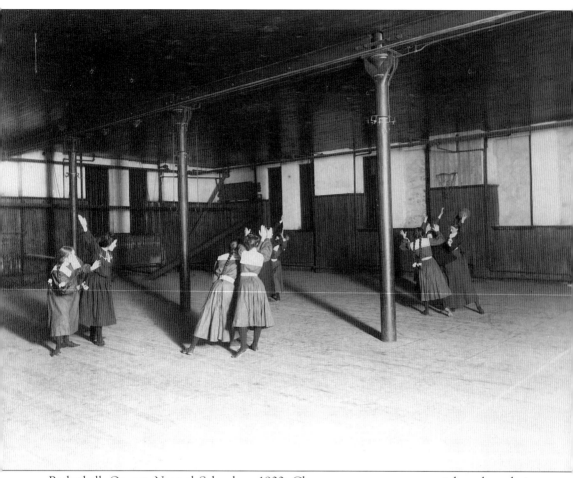

Basketball, Oswego Normal School, *c.* 1900. Close one-on-one coverage takes place during a gym class basketball game. Organized gym classes began due to the recognition in the late nineteenth century that exercise was essential to good health, although a close encounter with these mid-court pillars probably would not be.

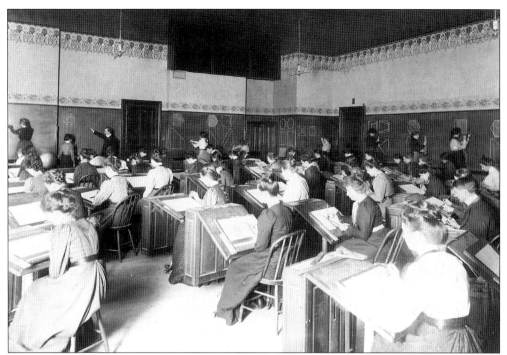

A constructive drawing class, Oswego Normal School, *c*. 1900. Whereas today's students may pick and choose classes according to the requirements of several major courses of study, in 1900 everyone was required to take the same classes since all were part of the preparation for a teaching certificate. In addition to English and math, art classes (like this) and other classes were required.

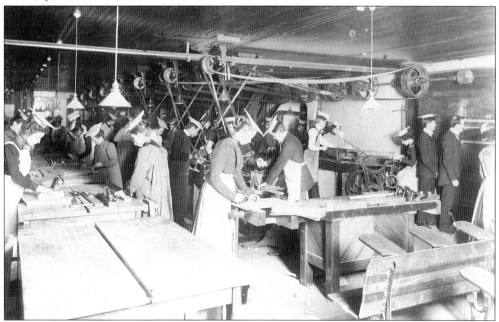

A manual training class, Oswego Normal School, *c*. 1900. The equivalent of "industrial arts," this was one of a variety of training classes offered in the early 1900s.

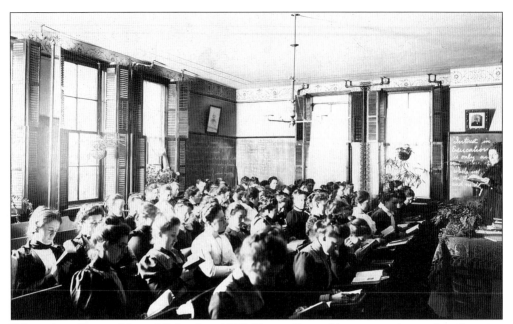

Ethics class, Oswego Normal School, *c.* 1900. Decorative and homey touches such as hanging plants, curtains, and stencilling above the window all make for a more pleasant atmosphere than most classrooms offer.

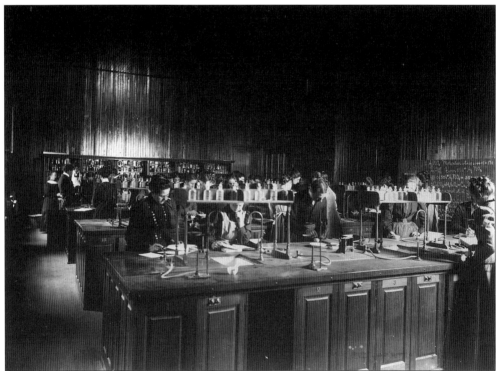

The chemical laboratory, Oswego Normal School, *c.* 1900. Bunsen burners, glass tubes, and scales—this was a the state-of-the-art, high-tech chemistry lab at the turn of the century. Note the complete absence of the familiar lab coat; just aprons were used.

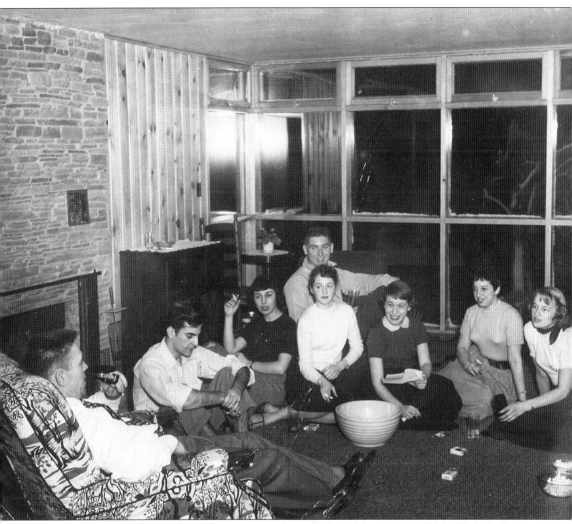

A creative writing class with Professor Rupert Stroud, State University of New York College at Oswego, February 1953. Oswego became part of the State University system in 1948 and consequently began a program of expansion, adding both classes and classrooms to the older Normal School structures on Washington Boulevard.

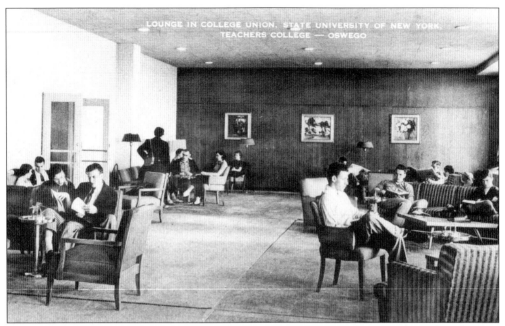

The lounge in the student center, SUNY Oswego, c. 1958. By this period, student lounges provided recreation spaces and meeting places on campus that once were provided exclusively by soda shops and lunch rooms in town.

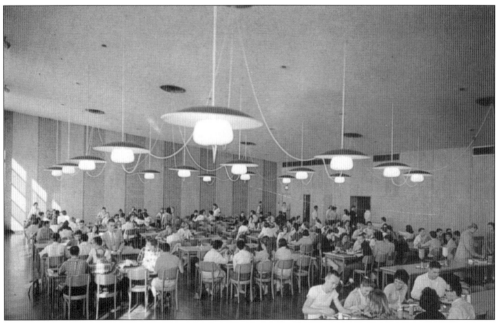

The Lakeside Dining Hall, SUNY Oswego, c. 1963. With the expansion of the campus in the 1950s and '60s, students no longer needed to room or take meals in town. The pendulum has since begun to swing back the other way as students elect to take apartments off campus.

St. Paul's Academy teachers, c. 1880s. While most of the children in Oswego attended public schools, the population has supported a number of private schools as well over the years, most of them with religious affiliations. Here, teachers from St. Paul's, located at 115 East Fifth Street, found time to visit the photographer. Standing are Anna Murphy, Josie Murray, and Julia Sullivan; Mary McGowan is seated.

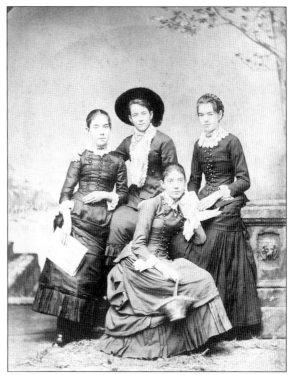

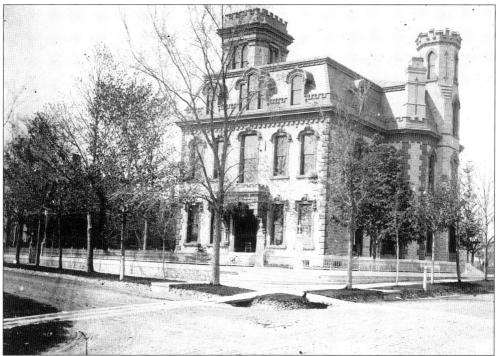

The Allen-Carrington House, Montcalm at West VanBuren Streets, c. 1895. This lovely building became the Castle School after the family moved out. The site is now occupied by a physician's office building; only the wall under the fence remains.

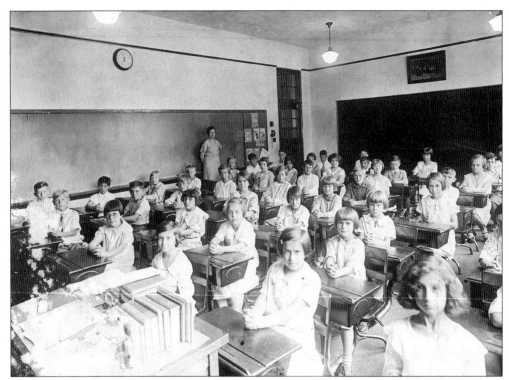

Ms. A.E. Donovan's third grade class, Kingsford Park School, *c. 1933*. Morning in Kingsford Park, on West Fifth Street, found the class sitting up straight for the photographer. In the third row from left, third seat from front, is Elizabeth Shortsleeve.

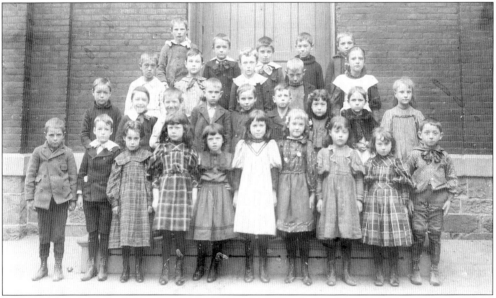

Third graders at School #6, East Fourth Street, *c. 1897*. Small neighborhood schools, like this one, often known as ward schools, once served the children of Oswego. They began to be replaced in the 1920s and '30s with larger, centrally located schools once transportation, in the form of buses, became available.

A janitor's cart, Sheldon Hall, Oswego Normal School, *c.* 1918.

Acknowledgments

The Oswego County Historical Society would like to thank the following individuals and agencies for their generous assistance contributing images and information for this book. In alphabetical order, they are: B & D Photo Services; Laura Malone Demore; Barbara Egelston, The Energy Center; Patricia Michel; Terry Myhill; Tim Nekritz, Harbor Festivals, Inc.; Janet Rebeor, Ed Vayner, and Associates; Scott Scanlon, Safe Haven, Inc.; Joseph and Cecilia Siembor; and Captain Donald Sweeney, Oswego City Police Department.

The authors would like to recognize the late Anthony Slosek, without whose dedication to the preservation and collection of local history this project would not have been possible. For over twenty years, Mr. Slosek served as the Oswego County Historical Society's volunteer curator and was responsible for gathering and preserving a large portion of the images documenting Oswego's rich history.